THE 30-DAY SKETCHBOOK PROJECT

MINNIE SMALL

Daily Exercises and Prompts to
Fill Pages, Improve Your Art and
Explore Your Creativity

PAGE STREET
PUBLISHING CO.

PAGE STREET
PUBLISHING CO.

First published in 2022 by
Page Street Publishing Co.
27 Congress Street, Suite 1511
Salem, MA 01970
www.pagestreetpublishing.com

Distributed by Macmillan, sales in Canada by The Canadian Manda Group.

26 25 24 23 22 2 3 4 5

ISBN-13: 978-1-64567-584-6
ISBN-10: 1-64567-584-X

Library of Congress Control Number: 2022933827

Cover and book design by Molly Kate Young for Page Street Publishing Co.
Photography by Minnie Small

Printed and bound in the United States

Page Street Publishing protects our planet by donating to nonprofits like The Trustees, which focuses on local land conservation.

This book is dedicated to anyone
with the courage and creativity to
conquer the blank page.

CONTENTS

Introduction 7

Warm-Up 9

Spend a couple of days getting into a new sketchbook routine and take the first steps toward meeting the blank page

Day 1: The Blank Page 10
Day 2: Introductions 17

Build Confidence 22

Get into the habit of creating without overthinking and start learning the basics

Day 3: Timed Challenge 23
Day 4: Color Palettes I—Color Harmony 28
Day 5: Drawing from Memory 33
Day 6: Gesture Drawing 38
Day 7: Collections I—Objects 44
Day 8: Master Study 50
Day 9: Black Paper 55

Explore Possibilities 58

Delve into your strengths and interests in art, and develop more advanced skills

Day 10: Minimalism 59
Day 11: Words 64
Day 12: Collections II—Sketchdump 69
Day 13: Thumbnailing 75
Day 14: Repeated Patterns 80
Day 15: Observational Drawing 84
Day 16: Monochrome Painting 91

Get Creative — 97

Generate endless ideas and develop a skill for imagination, innovation and out-of-the-box thinking

Day 17: Travel Journal — 98
Day 18: Toned Paper — 105
Day 19: Oceans and Skies — 109
Day 20: Recipe — 115
Day 21: Collage Paintings — 118
Day 22: Commission Yourself I—Ink Illustration — 124
Day 23: Color Challenge — 130

Challenge Yourself — 135

Get out of your comfort zone, try something new and push yourself with your most ambitious work

Day 24: Plein Air — 136
Day 25: Color Palettes II—Limited Palettes — 141
Day 26: Playing with Scale I—Miniature — 145
Day 27: Commission Yourself II—Flat Illustration — 150
Day 28: Playing with Scale II—Close-Up — 155
Day 29 : Alternative Self-Portrait — 160
Day 30: Realism — 165
Bonus Day 31: Embellish — 171

Acknowledgments — 172
About the Author — 172
Index — 173

INTRODUCTION

A sketchbook is arguably the most valuable tool in any artist's arsenal, and is easily the most versatile.

A home for your ideas, a place to learn and experiment and a springboard for personal expression, your sketchbook can be anything you want it to be. It can be somewhere to journal, capture memories and stick in scraps, somewhere to practice drawing skills with rough sketches and studies, somewhere for research and notes or a curated collection of beautiful finished pieces in one place. It can even be all of these things at once.

You might have several different sketchbooks on the go at any given time, or maybe your version of a sketchbook is a stack of loose papers gathered together in a particular drawer, folder or envelope. Regardless of what it looks like, or what you use it for, the one and only thing that all sketchbooks have in common is that they can't be done wrong.

In fact, getting good at making mistakes is a *fundamental* part of improving and enjoying your art. When you gift yourself the space to experiment and make a mess, you can begin to find solutions to whatever creative hurdles you come across and take bold steps toward becoming the artist you want to be. Your sketchbook is the perfect place to do that.

In this book, you will learn to feel at home in your sketchbook. You will get comfortable with the habit of creating freely, loosening up and building confidence in your work. And before long, you will learn to tap into your own inherent creativity to start coming up with consistent, unique ideas, from which you'll be able to start pushing your own boundaries and creating things you never thought yourself capable of.

My hope is that through these exercises and prompts, you'll gradually be able to develop a love for your sketchbook and a sense of comfort and endless possibility within its pages. By the end of this book, you should see not just an improvement in your art, but more importantly, a new outlook on the way you create and a new lifelong habit of artistry.

How to Use This Book

I have laid things out in a way that will work well with daily practice that progresses in difficulty week-by-week, though please feel free to take as much time with these exercises as you need. If it takes you multiple days to complete one exercise or you feel you'd like to linger on one specific topic for a while—go for it!

We start out with some simpler and quicker exercises that are designed to help ease you into the routine of finding time to make art every day.

If making time for this project every day is not possible, find a pace that works for you. The most important thing here is commitment and consistency.

It may help you to make a plan and to schedule in your sessions with this book and your sketchbook. You could use a habit tracker, such as a wall calendar, that you cross off for each day you complete an exercise to keep yourself accountable and create a visual achievement board to spur you on. If you find that you work more spontaneously, make sure you have your sketchbook with you at all times, so that you can tackle each day's exercise whenever you have a spare moment.

And if all you can manage is fifteen minutes while you wait for your morning train or ten minutes before you switch off for bed, then simply commit to that and work your way through the book a little at a time.

Each daily exercise is split into two sections. In the first, I will walk you through the concept of the day's practice, why it is important and how you can use it to enhance your future work. Then, I will guide you through a practice exercise that you can work on in your sketchbook to help you get accustomed to the new idea or technique. In the second section, I will give you a prompt that will allow you more space to develop what you've learned and transfer those skills into your own unique sketchbook page. I'll also share my sketchbook page inspired by each day's prompt if you're looking for an extra spark.

Feel free to simply work on the exercise portion rather than the prompt, or vice versa. You may even like to try two run-throughs of the book, one month where you get accustomed to each practice exercise, one by one, and the next time going through and exploring the prompts with your own ideas and the new skills you've developed.

What You'll Need

Don't rush out and stock up on supplies! If you have pencils, pens, paint and brushes, many of these exercises can be adapted to suit the tools you already have. We want to push ourselves to try new things and explore mediums we might not ordinarily use or find ways that we wouldn't usually use the ones we have, so get creative with how you make the exercises work for you—and, if you're feeling daring, try that medium you've always wanted to try but never knew where to start!

In this book, I use:

- Graphite and Colored Pencils
- Watercolor, Gouache and Acrylic Paints
- Scrapbooking and Basic Stationery Supplies
- Fineliner and Ballpoint Pens

If you are going to grab a new set of paints, pens or pencils, you don't need to own every single color that exists. If anything, I find that too many choices can be overwhelming and lead to muddy color mixes. Going back to basics and simply sticking with a standard mixing color set of Blue or Cyan, Red or Magenta and Yellow, with the addition of Black and White, will work just fine.

Finally, of course, you will need a sketchbook. In this book, I use a Stillman & Birn™ Alpha Series Sketchbook and a couple of beautiful handmade sketchbooks: one from Sketchbook Co. and one from pebblepeoplepaper on Etsy. All that matters with the sketchbook you choose is that the paper can withstand wet media and isn't so thin that your work will show through—think 110lb (200gsm) or up.

You might prefer a ring-bound or casebound sketchbook, something pocket-sized or the size of your desk, landscape or portrait, hard or soft cover. As long as it's something you're comfortable working in and a book you won't be too precious with, it is the perfect place for our journey to start.

WARM-UP

Spend a couple of days getting into a new sketchbook routine and take the first steps toward meeting the blank page

The first steps in any creative journey are always the most intimidating, so over the next two days, we'll ease into our new sketchbooking habit with a couple of easily approachable exercises designed to help you release the fear of failure and embolden you to take on this challenge.

Try to use these first days to work out an achievable length of time and an ideal time of day that you can commit to making art each day as we move forward with this project. And see if you can maintain an attitude of curiosity, openness and playfulness throughout, no matter whether your work goes to plan or not.

Now, if you're ready, let's dive in!

Day 1: The Blank Page

Is there anything more daunting to an artist than the blank page? In this void of white paper lurks fear and hesitation and pressure to live up to our own self-imposed expectations. But the blank page also represents endless opportunity. For our very first day of this challenge, we'll tackle the intimidating nature of the blank page head-on with some pressure-free exercises to get ourselves comfortable with making those first marks.

A quick note on using your sketchbook page-by-page: You don't need to start your sketchbook on page one. I tend to use my sketchbooks in no particular order. The reason for this is that flipping open to a page at random gives no context or added expectation to whatever I choose to create there. There's no pressure to make the next thing as good as or better than the last. It is a new day and a new project. If you haven't tried this before, I encourage you to give it a go. You might be surprised at the difference it makes!

One great way to get acquainted with your sketchbook is with some simple, relaxing watercolor patterns.

BREAKING IN OUR SKETCHBOOKS

What does it mean to break in a new sketchbook? Simply put, like we would with a brand-new pair of shoes, we're preparing the space to fit us more comfortably. How this relates to sketchbooks is that we're getting accustomed to the pages, choosing some at random to soften with color, texture and pattern. No longer blank, these pages can form backdrops for future artworks and offer a more inviting environment for future creativity to thrive.

There are many ways you can break in your sketchbook. It is a very personal thing, as you're essentially getting acquainted with your book of choice, and how you choose to do that may depend on what you have planned for it. For example, someone who primarily paints landscapes might want to prepare some pages with light washes of Blue or Ochre to lay underneath their future paintings and create a warm or cool undertone. Someone who likes to journal or scrapbook in their sketchbooks might want to stick in patterned or textured paper for layering over in future spreads. For people who sketch and take notes, it might be important to leave plenty of space for that, but they might also like to adorn their pages with borders or pockets and flaps.

EXERCISE
Taking the First Step with Easy Watercolor Patterns to Decorate Pages

Supplies

- 2–3 Watercolor Paints: No more than that, as the aim today is to keep things as simple as possible. I chose Phthalo Blue, Rose Madder and Medium Yellow as the typical Blue or Cyan, Red or Magenta and Yellow mixing colors, as they complement each other well and mix together nicely
- Watercolor Brush No. 4 (Remember: If you don't have watercolors, you can substitute the paint in this exercise—and many of the other exercises in this book—with whatever you have on hand.)

Simple patterns can be made from combinations of the elements dot, line and shape. With these as the basis, there are countless options for you to create a pattern and start to fill some blank space.

For each of these patterns, you might want to work freely across a page, or you could lightly draw a small box to work in as you practice, so you're not overwhelming yourself with the amount you need to do. For my practice, I worked within a 3 x 3-inch (7.5 x 7.5-cm) square.

1. To begin, choose a single color and brush a few teardrop shapes at random around your paper. They should all be similar in size, but this doesn't have to be exact. This is also a great chance to play with how adjusting the amount of water in your watercolor mix affects the opacity of the color you're laying down.

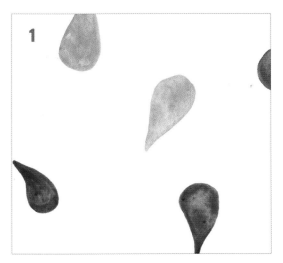

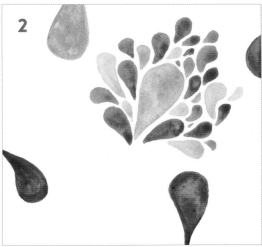

2. Next, start to paint smaller teardrop shapes coming away from one of the original ones. At this point, as well as varying the lightness and darkness of each one, try to see if you can make them different sizes to help them fit as closely together as you can without them touching. You might even need to curve some to help make best use of the space. And, if you have a small gap, you can fill it with a tiny teardrop or a simple dot.

3. Continue to work your way outward from that one main teardrop, until you start to get close to one of the others you originally painted. As you get close to the next teardrop, start the process again, painting smaller drops, but this time coming out from this other drop. Let the smaller drops from each central dot meet each other and try to fit them around each other as best you can without them touching.

4. Continue this process from each of the original water droplets until you've filled the entire page. This can be such a mindful and hypnotic exercise. It's such a wonderful way to relax and warm to the thought of painting, especially with a bit of music on; I feel like I could get lost in this exercise forever!

Want to try it again? You could also try this with other shapes, like dashes, circles or even random blobs.

5. The next exercise is equally as meditative. This time, choose two colors that you think will mix well together. I chose Pthalo Blue and Medium Yellow, knowing that they would mix to create a nice Green. Mix the two colors at random as you paint different-colored wavy lines across the page. Imagine you're looking at rolling hills, sand dunes or mountains as you let the lines meet without touching.

6. Choose one of your main wiggly lines and start to paint more rows of evenly spaced lines beneath it, following the same curves as the original line until you meet the next main line below it.

7. Continue this process, filling in the gaps with more rows of lines, mixing your colors at random—or simply using the same color for all of them. Both ways look great. Keep going until you've filled the page.

How about trying zigzagged lines? You can even see what effect you get with this technique using straight lines.

8. Our final warm-up exercise today is a fun way to start playing with shapes, layers and colors. Paint some different-sized triangles at random around your page. I used Orange and Pink along with Rose Madder, but this would look good with just two colors as well.

9. When the first layer is dry, layer more triangles in over the original ones, not covering them all the way, and continue to fill the gaps with different-sized triangle outlines.

10. Fill the rest of the gaps with dotted triangles and lines, switching between colors as you go. Have fun with shapes and layering, and fill as much or as little of the blank space as you like.

As with the dot and line patterns, this shape pattern can be adapted for any shape. Why not try rectangles and squares or more random blobs?

Feel free to repeat these exercises at any point throughout your journey with this book. If you don't have time for a particular day's prompt or you're not feeling up to the task but you still want to commit to your sketchbook time, think of ways you can create patterns like this.

PROMPT
Break In Your Sketchbook by Transforming 4 Blank Pages

Hopefully through these patterns, you've discovered how simple and meditative art-making can be, and how much you can do with a couple of colors and variations on simple elements.

With these patterns under your belt, and the concept of breaking-in your pages, fill at least four pages in any way you like. Continue to paint patterns, create borders with them or paint a page one flat color. Your only goal is to un-blank at least four pages.

TIP! *Color one page entirely in black, either with a piece of black paper or with your darkest matte ink or watercolor—we'll use this black page for a later exercise (page 55). Do the same on another page by filling it with a brown or tan color.*

IN MY SKETCHBOOK

After practicing the patterns, I chose to fill several more pages with some quick and effortless designs.

One option is to fill a page with a base color that you can sketch or paint over in the future, with the added benefit of a background to help it stand out from the page. I glued some torn tan paper across one spread and stuck in a piece of black mixed media paper on another, trimming around the edge to fit it with the sketchbook page perfectly. Next to it, I stuck in an envelope. I love adding pockets and envelopes to my sketchbooks as a welcoming and available space for any scraps or photos I might want to give a home to in the future.

(continued)

In one sketchbook. I painted a spread in one of my favorite watercolor colors, Quinacridone Burnt Orange. This page was a reminder that the aim of this practice is to be anything but perfect. As I set my sketchbook aside to dry, it fell face down onto the carpet, adding that dotted texture to the right-hand page. While it wasn't planned and didn't quite fit with what I'd had in mind for the page, the interesting added texture was a reminder to just go with the flow!

If you have any paper scraps or bits and bobs lying around, they can make great additions to a blank page, creating space to work around and on top of as you use the book over time. On the right-hand example, I just stuck a concrete texture I cut out from a magazine, the toned paper left over from the other page and some paint samples. Then, there's this feather I was sent in some snail mail that I taped in, too.

> **TIP!** *If you don't want to commit entirely to sticking things in, use washi tape! It can be a great feature and also is easy to remove without damaging the page underneath. This works well for sentimental photos that you might want to have in an album in the future.*

Gather any and/or all of your supplies, put on some music or a podcast or audiobook and see how many ways you can think of to add some color to a page. What about splatters or dripping paint down a page? You could rip or crinkle up the paper, make a pattern of holes with a hole punch, add pockets or borders, or draw or tape off boxes to work in in the future.

If filling pages like this doesn't seem appealing or useful to you, how about using a page or two to swatch all the colors of your favorite paints in a neat grid? Or, if you use a medium that benefits from it, gesso or prime some of your pages. Priming pages with a layer of gesso—which is like a thin layer of acrylic paint—helps to smooth and seal the paper and stop your work from absorbing or fading into the page.

Remember, our goal today is to discover how easy it is to just do something, to take the first step. When you have done that something, don't forget to give yourself a pat on the back for getting started. Well done for completing day one!

Day 2: Introductions

Regardless of whether you actively journal in your sketchbook or simply use it for drawing practice or finished paintings, each sketchbook is a snippet of your life at the time. In them, you can see a progression of your art and self, and perhaps even capture snapshots of moments—I know when I flip through old sketchbooks, I find certain pages can bring back vivid memories of the exact moment I was working on them.

With that in mind, supplementing or even filling entire pages with writing and annotation is another great, stress-free way of tackling blank space while also getting grounded in a moment of creativity. And, by getting inventive as you experiment with the layout and style of your text and how it can complement other elements on the page, your writing can enhance your sketchbook pages in a completely unique way. So, for the Introductions exercise, we'll spend some time getting familiar with taking notes in our sketchbooks and collaging components for balanced page compositions.

When it comes to what to write about, journaling is great for anything you want to remember, like book notes, art tips or instructions and drawing ideas. You could also document your current thoughts, mood or dreams and goals, your favorite quotes, recipes, trips you've taken, special days, trivia on a particular band, artist or actor, a list of your favorite films ever or what you've been watching, reading, listening to or playing recently.

EXERCISE
Creative Journaling with a Collage and Page Layout Ideas

Supplies
- **Different-Colored Pieces of Paper:** Cut or torn to different shapes and sizes. If you don't have different colors, or if you want more variation and texture, paint the paper yourself with ink or paint
- **Glue**
- **Random Photos:** Printed or cut out from magazines; look for words, people, plants, shapes, colors and textures
- **Colored Tape:** Try packing tape or washi tape, color your own masking tape or cut tape-sized strips of paper
- **Stickers**
- **0.1–0.5-mm Fineliner Pen**

Art journal pages are usually made up of a few different elements: writing, photos, doodles, drawings or paintings, larger text like quotes or headings, boxes and blocks of color or texture and collage. You can use as many or as few of these elements together on a page in an endless combination of layouts. As there are so many ways you could choose to lay out your page, it might help to mentally split the page into sections like thirds or quarters and have a single element in each section.

Writing

Lorem ipsum dolor sit amet, consectetur adipiscing elit, sed do eiusmod tempor incididunt ut labore et dolore magna aliqua. Quis ipsum suspendisse ultrices gravida. Risus commodo viverra maecenas accumsan lacus vel facilisis.

Lorem ipsum dolor sit amet, consectetur adipiscing elit, sed do eiusmod tempor incididunt ut labore et dolore magna aliqua. Quis ipsum suspendisse ultrices gravida. Risus commodo viverra maecenas accumsan lacus vel facilisis.

Headings and Quotes

Boxes

Photos and Collage

Backgrounds and Additions

Today's practice exercise is entirely optional. If it isn't your style or you're ready to jump into your own journaling session without any guidance, go for it. You might want your page to be more text-heavy, more minimal or bursting from the page with layers of collage, completely comprised of tape, paper scraps and printouts, or full of drawings and doodles.

But if you're looking for a place to start, we'll explore layering a simple collage of elements to create a nice focal point for your page that can be a backdrop for anything you want to add on top.

To begin, gather all your supplies. It's nice to spread everything around you and look at what you've got. Is there a particular color scheme or theme that's jumping out at you with the things you've gathered? If you're overwhelmed by the choices, start to narrow it down to a particular color group or theme, such as yellows and greens or pastel, or colors and pictures of nature.

1. Start the journal page with a background. It's easiest to start with the largest elements of the collage and then add smaller details bit by bit. Layer two similar-sized pieces of different-colored paper over each other with a slight offset, gluing the top piece to the bottom one so you can see the one behind. Add another strip of paper in the remaining gap.

2. Now, take a couple of magazine cutouts or paper scraps and place them over the first layer, using them to join one section to another.

3

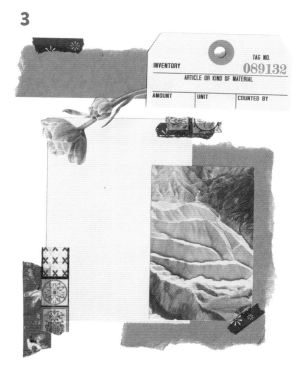

4

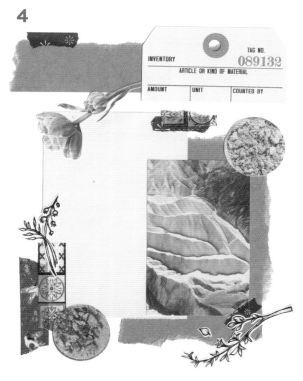

3. Going down in size again, use pieces of tape or smaller bits of paper to fill any obvious gaps and add small pops of contrast in areas that are lacking detail. Just leave the main, initial piece of paper relatively clear.

4. Finish off with some stickers around the edges and wherever you can see a big gap.

This is an intuitive exercise and one that is impossible to get wrong, so simply place and layer things in a way that looks right to you.

PROMPT
Document the Start of Your Sketchbook with a Snapshot of Yourself, Your Interests or Your Goals

Now that we know the elements that go into a journal page and different ways to structure or layer them, use this collage as a base. Use the Fineliner pen to fill the remaining empty space on your page with writing, or glue on a photo or sketch. If you didn't do the collage exercise, create your own combination of elements, and spend some time writing and documenting the moment.

If you need help with ideas for what to journal about, revisit my list at the start of this exercise or go with whatever feels right.

IN MY SKETCHBOOK

To begin with, I repeated a similar technique from the practice session to layer a few pieces of paper, stickers, tape and photos. I used the same photo as before at a different size and angle, and cut in different shapes to mirror the colors from the previous page in a more subtle way, and I achieved the same effect with the repeated use of the brown paper and tape.

I knew I wanted to fill some of the blank space with a simple painting, but wasn't sure what to do at first. Before letting myself overthink things, I decided to repeat one of the go-to patterns we worked on yesterday, but this time with a variation on the droplet pattern inspired by the eucalyptus cutout I had already stuck on the page. I painted some simple leaves with watercolor paint—not trying to create a masterpiece, just enjoying the process—and let the painting travel over the center line of the page to tie it in with the left page.

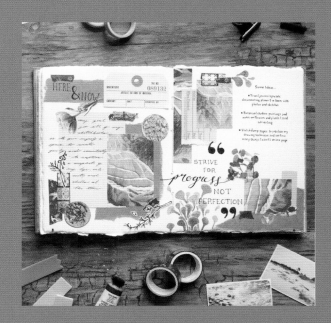

At this point, I had three clear blank areas I decided to fill with text. First, I wrote in a quote. There was still some blank space around it so I added some large quotation marks to frame it, which created a sort of border for the area and filled in those gaps. On the left-hand page, I wrote a heading purely to fill the space. Since the quote I chose spoke about progress, I tried to focus on the mindfulness element by writing "here and now" to remind myself to be in the moment.

Underneath, I roughly wrote about my goals for my sketchbook and the purpose of it for me. And then all that was left was the blank space in the upper right-hand corner. Here, I wrote a few ideas of things I could do in my sketchbook going forward. While the text before was freehand, for this one, I typed what I wanted to write, printed it and then used a lightbox to roughly trace it. This isn't necessary, but I like to combine text styles on a page. If you don't have a lightbox, you can tape the page up to a window or stick the typed text in directly.

The biggest challenge is knowing when to stop! It can be tempting to try to fill every available empty space and you can see that under the text there is a little bit of space left, but sometimes it helps to pause and consider whether adding more will enhance or distract from what's already there.

That said, if you're having fun adding and layering more, why not carry on! How many different combinations of elements can you come up with? And how many things can you write about?

BUILD CONFIDENCE

Get into the habit of creating without overthinking and start learning the basics

We've stretched our creative muscles, and we're all warmed up. Now it's time to ease into the creative habit with some exercises designed to build confidence and basic skills. Over the course of the next seven exercises, we will practice sketching and shading with pencil (page 33) and ballpoint pen (page 44), we'll learn to look for simple shapes and statements in our art (pages 33 and 38) and see how little we can do to make an effective impact. We'll also learn the basics of color (page 28) and even study from the great Vincent van Gogh (page 50).

By the end of this section, you will feel more comfortable with the fear of making mistakes, as you recognize that loosening up and simplifying your work gives you space to make art every day in one way or another, regardless of time or skill level.

Day 3: Timed Challenge

This is a fun one!

In a timed challenge, you draw or paint the same thing several times, reducing the amount of time you can spend on it with each attempt. As you get down to very short windows of time, you're forced to act quickly and decisively to make the most simple and effective marks that will convey the thing you're trying to draw. No longer aiming for perfection or realism, you'll settle for even the slightest resemblance to the thing you're trying to draw.

Because of this, timed challenges are a great way to loosen up, as there's no room for hesitation. You find yourself working quickly and fluidly without overthinking. And, if you're someone who struggles to get started with painting or drawing, a timed challenge forces you into action. The key is to approach the challenge with an attitude of playfulness. I can't imagine any of us expect to create a masterpiece in 10 seconds, so be prepared to create some silly-looking art. Trust me, trying to draw anything even in a more generous 30 seconds will result in some unexpected and often hilarious results.

On a more technical level, another benefit of timed challenges is that you will tune into simplifying what you're seeing into its most important component parts, as you have to be very selective with what parts of the drawing you spend time on. For example, if you were going to draw an eye in a limited time, you would know that you can't start by sketching individual eyelashes. You would start with the most obvious point so that if you don't manage to finish you would still end up with something that can be read as an eye, regardless of how realistic it looks.

Similarly, for our practice exercise today, we'll learn to see the forest for the trees—or, more specifically, see the tree for the leaves—in this quick but effective watercolor painting.

EXERCISE
Simplifying Shapes with an Easy Way to Paint Beautiful Trees in 1 Minute

Supplies
- Watercolor Brush No. 4
- Watercolor Paints: Green, Blue or Black, Yellow and Brown, optional. I used Sap Green, Yellow Ochre and Payne's Grey and had a muddy Brown already mixed on my palette

We're going to paint a simple watercolor tree to help us see how quick, simple shapes can give a good enough impression of whatever we're trying to paint. Through this exercise, notice how we're not looking at the details, like individual leaves or branches; instead, we are simplifying the tree down to just two simple shapes.

It's going to be a quick one, so don't aim for perfection. This is a very forgiving exercise—you can get away with making quite a mess and still have it look like a tree if you can learn to trust the process.

1

2

3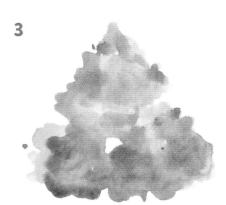

4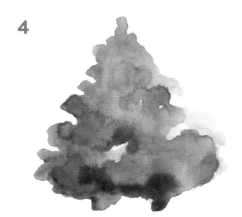

5

1. Roughly brush a small triangle of Green paint toward the middle edge of your page.

2. Roughen up the edges with some wobbly lines and maybe a few dots of paint on the outside of the shape.

3. Paint two more wobbly triangles like this. Paint one next to the first and a third on top of them both to form one big wobbly triangle. You might end up with a gap between them, and that's completely fine.

4. While all the paint is still wet, use Blue along the bottom edge of the shape, dotting it in loosely and letting the paint blend out however it will. Add random drops of the same color around the middle of the tree, especially above where you've left any white spots. This is the shadow of the bunches of leaves.

5. Your Green paint should still be wet at this point, and you can add some Yellow around the tree at random that will bleed out and blend with it.

6. You might want to add a bit more shadow at this point to the underside of the tree. Then, use Brown, if using, or the Yellow you used earlier to paint a thick line from the bottom of the tree to the bottom of the page. Press the bottom of the line with your finger to smudge it out.

7. Add a couple of thin bent lines from the tree trunk up into the base of the tree. If the shadow from the underside of the tree runs into the branches, that's great, it'll look like more shadow. Keep adding branches as you see fit.

Note how long it took you to paint your tree. Now, commit the instructions to memory and try this all again, this time as quickly as you can and in less time than the first effort. If you're having fun, you can do this as many times as you like! Try to get a bit faster each time. Or, what about looking at painting your trees in different shapes and colors? See how many you can come up with in such a short space of time.

PROMPT
Loosen up with a Fun, Timed Drawing Challenge

The goal with any timed challenge is to simplify the subject of your drawing or painting into the most basic shapes it can be. Choose something to paint three times: first for 30 minutes, then again for 3 minutes and finally for 30 seconds. Try painting a bird or a flower or vase of flowers, an apple, orange, pear or an eye. You could do this exact exercise but with a different medium: try drawing, rather than painting, to see what challenges and advantages that raises.

Keep that final painting or drawing as simple but as impactful as you can, squint your eyes if you have to and identify the shapes that will give the clearest impression of what it is. Keep it loose and playful, and don't forget to have fun. If nothing else, this is a great way to learn to laugh at yourself and the silly art you make.

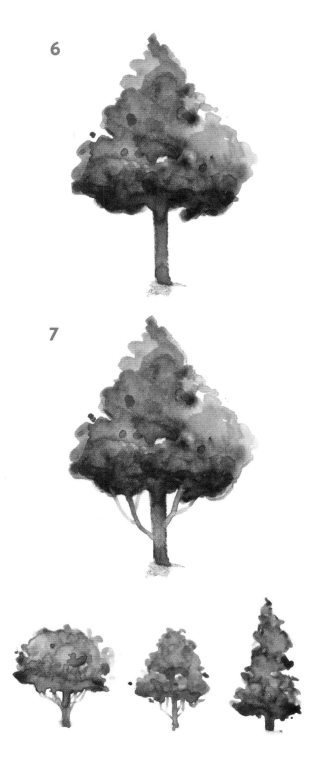

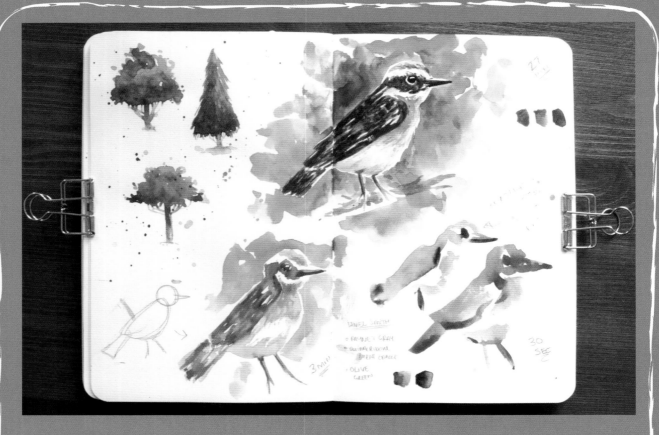

IN MY SKETCHBOOK

I decided to paint the first prompt suggestion: a bird. This one is a whinchat, a small brown singing bird. I used Daniel Smith watercolors in Payne's Grey, Olive Green and Quinacridone Burnt Orange, as well as whatever colors were already dried onto my mixing palette.

I also used only a Watercolor Brush No. 8, which was round with quite a point for details but big enough for large, brave strokes.

For the 30-minute bird, I started with a very light sketch to map in the basic shapes that would make up its body. I didn't include a lot of detail, but made sure the general shapes and angles were right, and the legs and eye were in place.

The painting portion began with a light wash of Grey on the underside of the belly and a Light Orange under the chin. These were made up of very loose, chunky brushstrokes. I wasn't sure how much I could get done in the time, so I wanted to get as much visual information down as possible, only going back for details if I had time later. Next, I painted a slightly darker strip along the face, leaving a gap for the eye and led that into the beak and down into the shape of the wing. With the wing, I made sure to leave some gaps in the paint to show the markings on the feathers.

I repeated this process, this time with slightly darker versions of each color, and, rather than large brushstrokes, now using the point of the brush to dot and swipe in the suggestion of individual feathers. I mixed a much darker Brown, and I filled

in the face and wings some more. Then, with about 15 minutes left on the clock and while the latest layer of paint dried, I quickly surrounded the bird with green. This made a huge difference, as it gave the bird some context and also allowed me to show the white feathers around the belly and on the top of the head with the use of negative space.

Feeling more confident with my time, I created a dark mix of Payne's Grey and Orange, and darkened up the wings with more suggestions of feathers. I added the eye, leaving some blank space as a highlight, and I painted the underside of the beak. I also used this very dark color to dot in some more feathers around the eye and painted the legs with a couple of simple strokes.

For the 3-minute painting, I initially didn't think I'd have time for a sketch, but I decided to try anyway. The sketch was made up of the simplest of shapes—you can see it recreated here next to the painting—and it took about 10 seconds. Again, I started with the Grey of the underbelly and Light Brown for the chest. While it was still very wet, I deepened both of these colors where needed. I stuck mainly to Payne's Grey for the feathers, not bothering to mix a good Brown. Leaving some gaps for feathers, I painted the tail, wings, around the eye and beak in one continuous line. I then went in with darker Grey under the beak and the eye. The color did bleed, but that's unavoidable and it added a sense of shadow around the eye that I quite liked anyway. I added simple legs and then had enough time again to very quickly add a light wash of background, again with the intention of showing the white feathers on the chest. With a little bit of time left, I mixed a little Brown to add to the wings, neck and top of the head.

The 3-minute round was quite a challenge, but the previous round had helped me pinpoint the parts that made the most difference. For me, that was the dark strip of color that runs from the beak to the tail, the eye and the background.

To give myself a fighting chance with the final painting, before pressing start on my timer, I loaded my brush with this versatile mix of Grey and Orange, and I decided beforehand what steps I would take to get as much down on paper as possible. I again painted from the beak down to the tail in one swoop of that color—this time not bothering to leave the white strip on the head but leaving space for the eye. I used the same color for the underside of the belly and then a plain Orange for the neck. With a few seconds to spare, I added the eye, and I tried to add shadow to the underside of the beak and wing and added the legs.

With that one under my belt, I thought I'd figured out a good technique so I started again (this can be such an addictive practice, and it is often over too soon!). But I started the second painting too close to the first and felt limited in what I could do. That one wasn't successful at all, but the joy of these quick paintings is that there's no sense of having wasted your time when they don't work out.

It is so hard not to have fun with this, if you're willing to look at it with lightness and humor. Though it seems like you're messing around, you're also learning to communicate shapes in their simplest form, learning to simplify and simplify until a bird becomes two brushstrokes and you pinpoint the absolute essentials to get the image across.

> **TIP!** *If you'd like to know more about painting birds in watercolor, stay tuned for a detailed breakdown in the Day 23 exercise (page 130).*

Does your 30-second painting look like what it's meant to be? Show it to someone and see if they can guess what it is. And don't be afraid to keep trying with that quick painting to see what brushstrokes make the most impact. You can do another 10 in five minutes if you want to!

Day 4: Color Palettes I— Color Harmony

With endless possible combinations, understanding what colors can be put together in a way that is pleasing to the eye or a way that conveys a particular mood or style is a complicated and multifaceted topic. Today, we'll scratch the surface with our first steps into the basics of color harmony.

You will probably be familiar with the color wheel, with the primary colors Red, Yellow and Blue equally distanced apart and the colors between them being made up of their respective mixes. There are various ways you can split the wheel to create color combinations that are grounded in reliable balance. Here are a few examples:

Monochrome

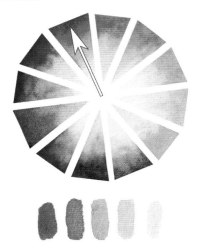

Monochrome palettes are made up of a single color with variations in how light or dark it is. We'll delve deeper into this on Day 16.

Complementary

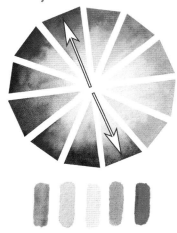

Complementary colors sit opposite each other on the color wheel and can make for some beautifully contrasting paintings. For more subtle uses of this mix, you can choose one dominant color and use the other in lighter or more muted shades.

Analogous

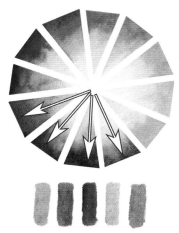

Here you take neighboring colors, like Yellow, Green and Blue, and can create a clear and obvious mood. Combinations like this are common in nature and can give your work a sense of calm and harmony.

Triadic

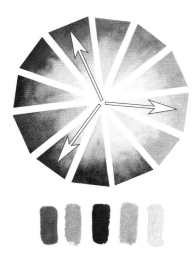

These palettes take the colors from each third of the wheel and can be very contrasted, if you use the most saturated version of each color.

Split-Complementary

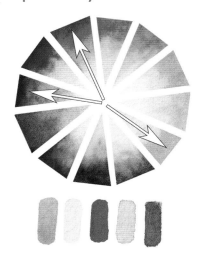

With these palettes, you can achieve a similar sense of contrast as in traditional complementary schemes, but the split-complementary is a little more mellow.

This is the type of palette we'll use for today's practice exercise.

1

2

3

EXERCISE
The Basics of Color Theory with Swatching and Color-Mixing

Supplies
- Watercolor Paints: Red, Yellow and Blue
- Ruler
- Pencil (I used a red colored pencil, but any pencil will work fine)
- Watercolor Brush No. 4 or No. 8

Our split-complementary palette will be made up of Red, Purple and Yellow-Green. You may want to begin by experimenting with different mixes of your primary colors, swatching them on your page until you're happy with the Purple and Yellow-Green you create.

1. With a ruler and colored pencil, lightly draw in a couple of lines to split your page into three random sections.

2. Draw more lines at random angles that intersect the first and span the entire page.

3. Continue to draw lines like this, concentrating now toward the center of the page. Keep connecting the lines and shapes and corners until you're happy with your abstract geometric pattern.

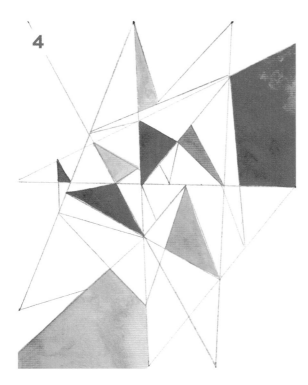

4. With the Red paint, use your brush to begin to fill in some of the shapes. Use more or less water in your paint to achieve lighter or darker shades of Red. Paint areas that are spaced apart for now.

5. As the paint dries, paint in more shades of Red, this time with some next to other shades of Red, but try not to let them blend together.

6. Once this is dry, do the same with different shades of the Yellow-Green you mixed, taking care to stay within the lines.

7. Finish off by doing the same with your Purple color to fill the final gaps. Notice how the different colors and the different shades of colors look next to each other. Despite being so contrasted, they make a pleasing combination.

You could use this method to come up with engaging color combinations for any future paintings. Experiment with the different types of palettes to see how the colors interact with each other and what mood they convey.

PROMPT
Create a Pattern with a Harmonized Color Palette

Draw a similar pattern of lines and shapes, and choose another combination of colors—monochrome, complementary, triadic or analogous—based on what we've learned. Spend some time swatching different combinations of each if you like, or dive straight in with your palette of choice and fill the page with a beautifully harmonized pattern.

IN MY SKETCHBOOK

I chose an analogous palette of Yellow, Yellow-Green, Green and Blue-Green for my color pattern, and I used various round items from around my desk to draw around and create this circular pattern. Sticking within the curved lines of this pattern was much more of a challenge than the straight lines of the practice pattern, but the circles do bring their own fun element of style to the piece.

Day 5: Drawing from Memory

Using your memory as your only reference is an incredibly valuable skill to learn. With a catalog of different objects and elements in your head, you can draw confidently with a greater understanding of how things are made up and even combine all that knowledge to create entirely new things. Drawing from memory can even encompass things like a memory of how different lighting affects objects or a mental image of something from all different perspectives. Getting to that point takes a lot of repetition, initial practice and observation, so, for today's exercise, we'll start to stretch those visual-memory muscles.

This challenge is also another great way to shake off any expectations of perfection and just see what you end up with. Most of us aren't blessed with a photographic memory, so whatever we draw with our memory as our reference is unlikely to be identical to the real thing. Understanding and accepting this can be quite a comfort, and, rather than aiming for a perfect finished piece, we can concentrate on building the important skill of observation, training ourselves to really look at what we're drawing and to understand the shapes, lines and angles that come together to make up the whole.

Even the simplest sketches can be a challenge to recreate from memory. Try it with a couple of random shapes, drawing a couple of irregular shapes or lines together, and then covering them and trying to redraw them exactly. It's amazing how quickly you can forget the details when you're not actively trying to take them all in!

With that in mind, let's push ourselves with a more complicated sketch.

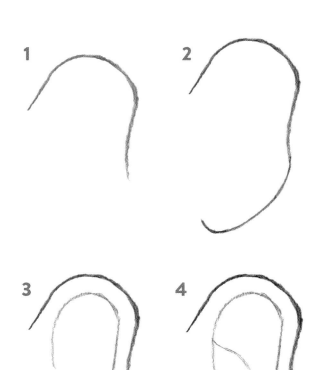

EXERCISE
Beginner's Pencil Sketching and Shading while Drawing an Ear from Memory

Supplies
- Pencil: I used No. 2B

First, we'll learn how to draw an ear, then we'll see how much information we've managed to retain by trying to draw it again from memory.

1. Start your ear drawing with a C-shaped curve with an elongated tail.

2. Continue the curve into a soft rounded shape at the bottom to form the shape of an ear.

3. Inside this shape, lightly draw an open-ended oval toward the top edge of the ear.

4. Now, from the opening of the inner oval, draw a swirl that curves back in toward the center of the ear and has a bumped edge on the outside. Take a second now just to look at this basic sketch and try to commit these shapes to memory.

5. Next, shade in the bean-shaped inside of the ear as dark as you can, and then lightly shade the rest of this low inner ear area in one even shade. Try to start your shading as lightly as you can and build it to a Medium Grey.

6. In a similar shade, color a curved diamond shape to form the upper inner edge of the ear. Darken these shaded areas toward the edges.

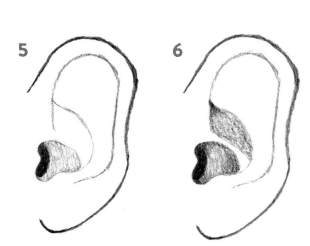

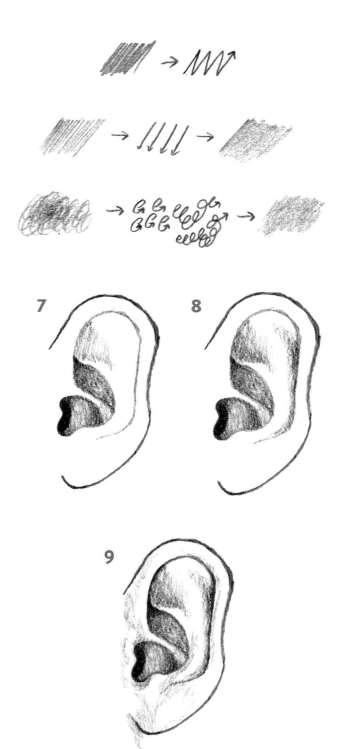

7. Continue with a triangle of shading above the inner ear. Then, lightly shade the gap between the two darkest portions.

8. Darken that shaded area toward the bottom, and create another area of shading along the inner side of the ear that is darker as it gets closer to the crease.

9. Now, with very light strokes, finish the ear with light areas of shadow in areas like the earlobe and where the ear would meet the face. You can also use this moment to darken or neaten up any of your outlines and make sure there is still contrast from one shape to another.

 When you're done, take a moment to really look at your drawing. Try to remember as much as you can about the shapes and shades.

10. OK, now it's time to cover up your drawing, and try to draw the ear again. Try not to look at your first drawing or the instructions. How much can you remember? You might find it helps to follow the exact order as before, or you might want to start with the things that you remember most.

11. Now, reveal your original drawing and compare the two. How do they differ? What did you miss? Look at the differences, and, if you want, draw the ear again with that in mind. Pay attention to areas where you were missing information, for example where you placed shadows or how the different angles interacted, and aim to focus more on those aspects next time.

PROMPT
Draw Something from Memory to Test Your Observation Skills

If you're up for the challenge, and with a deeper understanding of just how much observation goes into an accurate drawing, why not try again by drawing something else in your sketchbook and then repeating it from memory?

Now that you've had some practice, you'll find that you're a lot more mindful with your first drawing. You might also find that you're approaching this first drawing differently, breaking things down in your head into simpler shapes that will be easier to remember for next time, which is such a useful skill to have for all of your future drawings, not just ones you're trying to remember!

As with before, when you're finished, analyze how you've done. And, feel free to keep trying as many times as you like.

IN MY SKETCHBOOK

I don't know about you, but I ended up drawing much faster when it came to my drawing the ear from memory, maybe in an attempt to get as much information down as I could before I forgot it.

Remembering where each line met the other and how the lines curved was my greatest challenge in recreating the ear—that and resisting the urge to look at my first drawing! In the end, I knew I wouldn't be able to recreate it exactly, so I just tried to focus on the things I did remember and make the best of it that I could.

To compare them both, the inner part of the ear is much smaller in my memory drawing, so I know that's something I'd improve on if I were to do this again.

Afterward, I drew an apple core and snail.

I learned from the apple drawing that I wasn't paying much attention to the overall shapes, so I tried to make that my focus going into the snail sketch. As I drew the shell the first time, I actively made an effort to pay attention to the angle of the circles and how many there were.

When it came to recreating it from memory, one area where my mind drew a complete blank was with the shading of the bottom of the shell. You can see in the first drawing on the right that it's much darker, but I couldn't for the life of me remember that. Thankfully, one of the perks of these drawings is that you're forced to get comfortable with mistakes and improvisation, so I just did what I could to try to make it look OK, regardless of whether it would match the original or not.

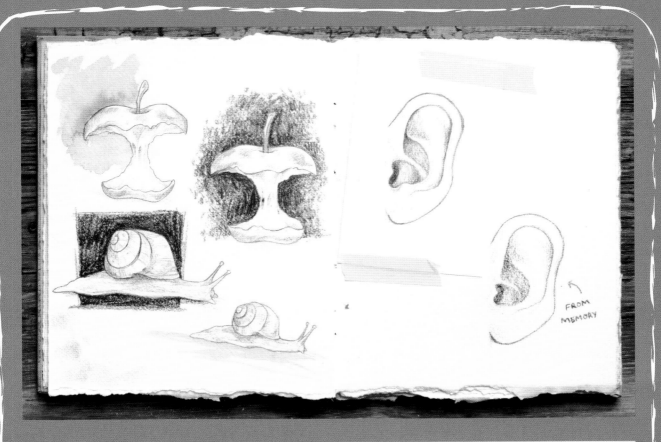

FROM MEMORY

To finish off the page, I used some of the paint left on my palette from the Timed Challenge (page 23) to paint around some of the sketches; sometimes, when I have random objects floating around on the page, I like to fill in some of the dead space with shading or color, boxes and borders. It isn't necessary, but it's nice to differentiate one object from another and just fill the space.

You might see some graphite smudges on the bottom of the page. These are usually easily erasable, but I think there's something quite characterful about a lived-in sketchbook that contributes a sort of vitality to the art on its pages. If nothing else, it's important that we not be too precious with our sketchbooks, or we'll never use them!

TIP! *If smudging graphite becomes an issue that is interfering with the art in your sketchbook, keep a piece of printer paper or tracing paper between your pages to stop the work transferring from one page to another, and keep a clean sheet of paper between your hand and the page to prevent smudging while you work.*

The challenge of drawing from memory is a great introduction to the concept of observation. After this exercise, you might find yourself looking at the things you're drawing much differently from how you usually would, taking much more time to take in all that you see.

Day 6: Gesture Drawing

Sketching the human form in dynamic poses can be a quick, simple but effective way to stretch your creative muscles and come up with some engaging and lively drawings. For more detailed figure study, it's very beneficial to understand at least the basics of anatomy, to make sense of how the body is made up, learn where you would typically find things like masses of muscle and fat, and how and where the bones and joints connect. This knowledge allows you to better fill in the gaps with that prior understanding of the key shapes—like the mental library we talked about—when you're trying to work quickly and fluidly.

Regardless of how well you know the anatomy of the body, quick gesture drawings can be made with a simple combination of curved and straight lines, and can efficiently capture the essence of the body. This is a great technique for capturing the body in movement and, when used as initial sketches, these gesture drawings can be developed into more detailed drawings and paintings that retain an incomparable sense of flow.

For our practice exercise today, we'll learn the very fundamentals of figure study and simplifying the forms of the body to achieve quick gesture drawings.

EXERCISE
Capturing the Basics of the Human Form with a Figure Study

Supplies
- **Graphite Pencil**

A great way to test our ability to capture motion in a gesture drawing is by studying a dancer. Often their actions are stretched and exaggerated in ways that make our task of observing the key components of movement much easier.

With any gesture drawing, let's begin by looking for the clearest line of action. This is generally a curved or straight line that runs through the motion of the body, showing the direction it is leaning in or where a majority of the body's weight is resting. You can also look for the positioning and curve of the spine or how the rib cage and pelvis are interacting. These are the core elements to begin with. With these in place, the remaining drawing will retain a sense of movement while still being grounded and balanced.

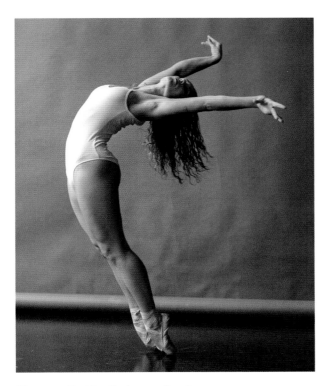

Photo credit: Yan Krukov on Pexels

1. Our line of action here is quite clear, as it runs in one long curve from the dancer's head to the tip of her toes. The same curve also travels up to the tip of her fingers. Start by drawing a curved line to match this.

2. Next, use a bean shape to draw the form of the rib cage where it rests along the curved line. Draw the pelvis and head in here, too.

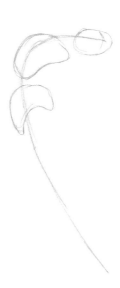

3

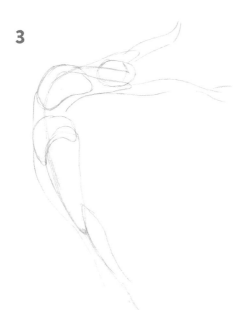

4

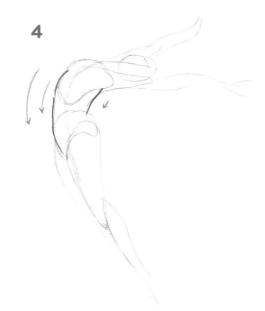

5

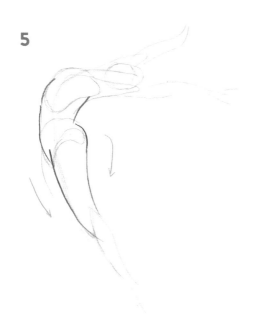

3. Begin to loosely flesh out the mass of the body and the limbs with a few wavy lines. It doesn't have to be detailed at all, just get the overall shape of the body. It might help you to pay attention to the negative space around the body to get a sense of the different angles and curves and the space that the body is taking up.

4. We'll begin to add detail to the form now with darker and more deliberate lines. Use one or two sweeping motions for each line, then move on to the next. Draw a curved line from the chest down the torso to the start of the legs. For the back, draw one short straight line.

5. For the leg, curve a line from the lower back down to the knee. Start the inside of the leg with a straight line that curves as it reaches the knee.

6

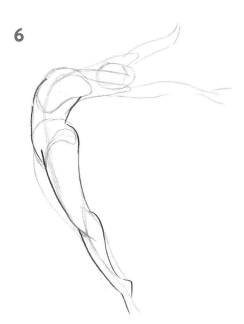

7

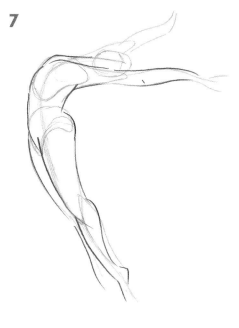

TIP! *For any gesture drawings, as you flesh out the limbs, use a balance of curved and straight lines, and be wary of turning the arms and legs into a series of connecting sausages. Instead, let your curved and straight lines overlap in places to suggest areas of softness and tension.*

6. Finish the leg with similarly curved lines for the calf and a small right angle for the heel of the foot.

7. Draw the other leg in one or two lines that follow the curve of the body. Add the arm and chest with more decisive lines that outline the body.

8. For the arm in the background, use another combination of curves with a straight line at the back of the arm. Outline the head now.

8

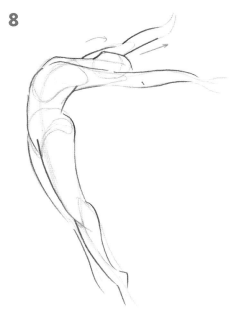

9

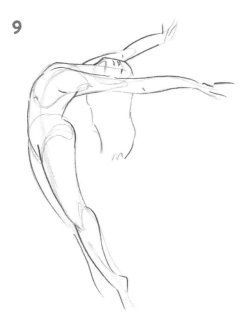

10

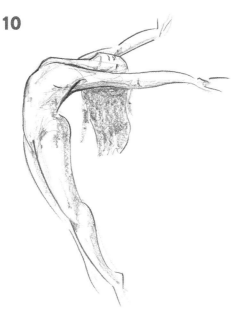

9. Add details, like a few lines to suggest the hands and fingers, small slivers on the face where the eyes, mouth and nose are and some hair flowing down toward the feet.

10. You can also lay your pencil as flat as you can and use its broad surface to add shading to the right side of the body.

PROMPT
Draw 3 More Poses to Capture Movement and Gesture

With this understanding of the power of combining curved and straight lines over a quick sketch of the body, try to fill a page with dynamic poses. One way to do this would be to watch a yoga video and sketch the forms as the instructor holds each pose. Or, why not combine this with the simplifying techniques we learned in the Timed Challenge (page 23). Draw the same pose at varying lengths of time with less and less detail as you get more accustomed to the construction of the body.

Remember to be patient and intentional with lines. Slow down, and make decisions in your head before making marks on paper. How can you use your lines sparingly to capture the movement of the human body?

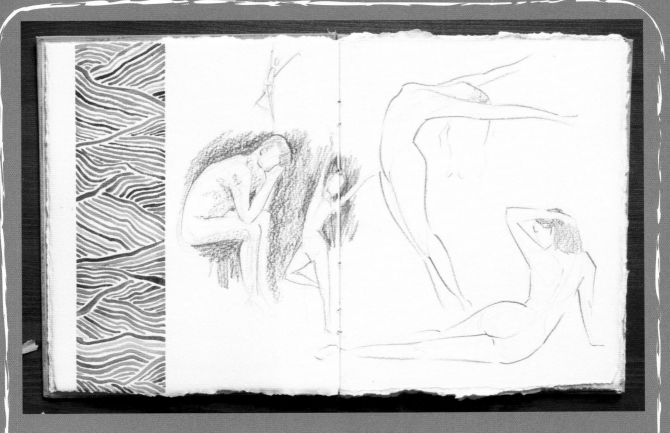

IN MY SKETCHBOOK

My sketchbook page today did not get off to a great start! I first chose to draw a seated male figure. The initial sketch captured the curve of his back and the harsh angles of his legs quite well, but I found that as I filled in the bulk of his body, the interesting perspective and foreshortening on the limbs in the background became too complicated for me to communicate in a few pencil marks. The more I drew, the more I lost the initial flow of the drawing. I persisted and added shading, but overall, this one was lacking the sense of gesture I was aiming for.

I moved on to another dancing figure, where I was able to have a bit more fun with the stretching of the body in motion. I think because I was working too small here and on the edge of the page, I wasn't able to be quite as expressive as I would have liked, but the overall outline of the body is there and conveys just enough of the pose. I drew the seated figure on the right next and had much more fun with sweeping pencil marks making up the body.

These sketches were a reminder that this entire project—and sketchbooks in general—are all about practice. Within these pages, while I did get frustrated at my drawings not going to plan, I was able to try and try again until my final sketch was one that I liked, because I had settled into the drawing process and whatever the outcome might be.

Remember that your sketchbook pages aren't here to be perfect; their beauty comes from the time spent in them and the lessons learned on them.

Day 7: Collections 1—Objects

One of the eternal struggles of an artist is coming up with what to draw. The topic of Collections is a broad one, but great to lean on in times of art block. Put simply, when you draw a collection, you're just drawing *things*, or objects. But by narrowing them down to a collection, or a certain category, you're limiting the overwhelming sense of having to choose something to draw out of every single thing that exists. Instead, you'll focus on everything you can think of within more specific constraints, such as fruits, vintage toys or types of daffodils.

You can fill a page with as many objects as you can think of and even combine categories, or you could choose a group of things, write a list of them and draw one a day, knowing that you'll always have a backup drawing idea at the ready.

Collections can vary in specificity—you're really just aiming for a bunch of different things on a page—so, if you're a chronic social-media-scroller, drawing collections of the things you come across online is a great way to make the most of that time. If you want to narrow down your options, draw something like every face you come across. You'll find your time on social media is much more mindful when you're actively looking out for things to draw.

We're going to take in the space around us by drawing the collection of objects we currently have within reach.

EXERCISE
Ballpoint Pen Sketching by Drawing These Scissors

Supplies
- **Black Ballpoint Pen**
- **Graphite Pencil**
- **Eraser**

For our exercise portion today, we'll build on the sketching skills we learned when drawing the ear (page 34) a couple of days ago, this time challenging ourselves to work with a ballpoint pen. Shading with ballpoint pen is an exercise in patience and focus, as you must pay attention to the pressure you're using, remembering that unlike pencil, there is no undoing a mark once it is made. Because of this, your only option if things don't go to plan—other than starting again—is to accept wherever your drawing ends up and do your best to make it work.

First, to get used to the amount of pressure needed, let's practice a few gradients with the pen.

Use the same shading technique as we learned in the pencil sketching exercise, and make all your strokes go in the same direction rather than in a zigzag motion. Pick your pen up between strokes and work in quick, light, streaking motions.

Draw a rectangle. From one end to another, start shading with the lightest touch possible and very gradually increase pressure until the other end of the rectangle is shaded as darkly as you can. When it comes to darker shading, don't aim just for pressure—you can also rely on lots of lighter layers of shading over each other.

TIP! *Ink tends to build up in the nib of the pen, so keep a scrap of paper on hand to regularly wipe off any excess ink. You might also want to keep a clean sheet of paper between your hand and your drawing to minimize the risk of smudging.*

Once you're happy with your technique, let's start with this sketch of some scissors.

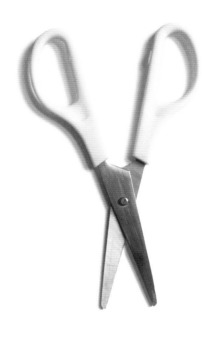

1. In pencil, lightly draw a long, narrow cross with the point where they cross around two-thirds of the way down.

2. For the handles, draw a curved C shape outward from the top of each line. For the blades, draw a thin triangle from the bottom of the X to the halfway point. Square off the bottom of the triangle and draw another one on the other line.

1

2

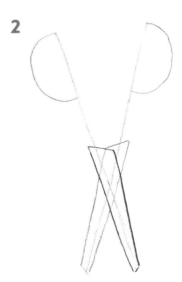

3

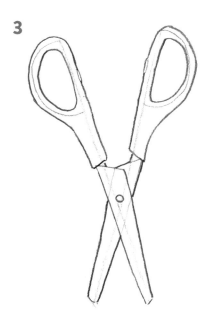

4

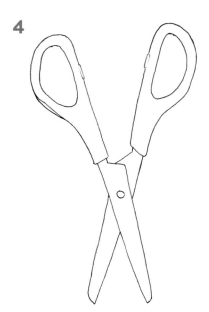

5

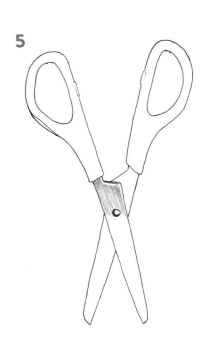

3. Use the guides to flesh out the handles, and add a small circle where the two blades intersect.

4. Draw over the pencil lines with the ballpoint pen, and erase your pencil. Don't worry if your outlines aren't perfectly neat, just try to keep a firm grip on your pen and try not to press too hard. Go slowly, and don't be afraid to move the page around if you think another angle will be more comfortable.

 You can see where I struggled with one of the curves. Rather than starting again, we'll just see if I can make it blend in as the drawing progresses. I find it important to give all my drawings a chance, even when they feel like they're not going to plan. Quite often, a solution presents itself as you go along.

5. It's time to start shading with your pen. Remember to keep your lines light and consistent in direction. Luckily, there is a clear grain to this piece of metal, so we'll follow that and it won't matter too much if the shading comes out streaky. Shade about 1 inch (2.5 cm) down the blade, leaving the page white along the top and outer edge of the blade. When that is done, add a little bit of shadow along the top of the blade and lightly layer some shadow under the joint.

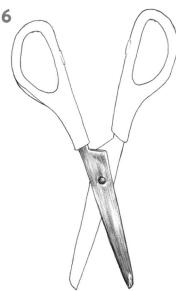

6

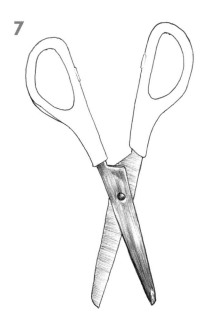

7

6. Continue down the blade like this in sections about an inch (2.5 cm) long. Don't worry about your shading overlapping; the blade gets darker as we go down, so color it as consistently as you can at first and then go back and darken it with the same light strokes, working your way back up from the bottom. Leave a small bit of white on the joint and at the bottom of the scissors blade.

7. The grain on the other blade goes the other way, which provides another great opportunity to practice, this time with shorter strokes. You can see that I was less successful with the smooth shading, but, as a whole, that doesn't make a difference as long as the overall shade is consistent. So don't be disheartened if you're struggling to avoid streaks. As you go, you might also want to darken the outlines to bring them back out in contrast against the shading and to cover any edges you may have colored over.

8. With equally light strokes, gradually build up areas of shadow where the blades intersect and where the handle starts. Also, very lightly add the scuff marks to the inside edge of the blade with a squiggly line and a few scuff marks along the blade that you can add at random.

8

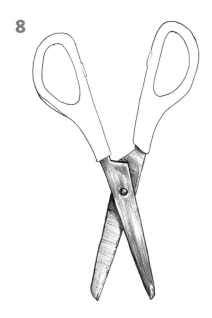

9

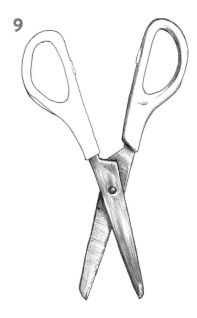

10

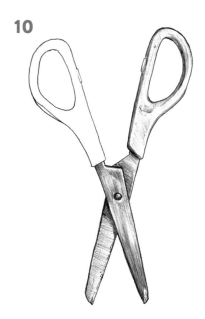

11

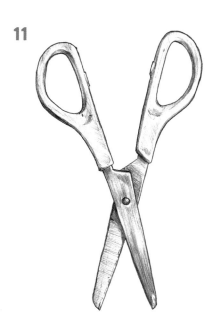

9. Color in the darkest areas of shade you can see on the handle. With such thin areas of shading, I find it easiest to follow the contour of the outline.

10. To fill in the rest of the handle, shade it all light-ly, leaving some areas blank for the highlights. If achieving a very light tone is impossible, you can space your shading lines apart more to achieve a lighter look.

11. Do the same on the other side, lightly shading the handle and leaving areas blank to show light. Remember to start with one consistent color first, then go back over in a few areas to give shading and an impression of dimension.

I darkened my shadows considerably to cover the wobbly line, and I thickened the outline to cover where the ink line had become blotchy from not cleaning off the pen nib regularly enough. I'm glad I didn't start this one from scratch after that initial mistake! After working with it, you'd never know a mistake had been made.

PROMPT
Build the Habit of Drawing Everyday Items and Fill an Entire Page with Them

Drawing collections of things can be used to document a particular interest of yours or a snapshot of your life and the things you own. Like old still life paintings that captured the qualities of a moment or era with a snapshot of its relics, you too can curate a collection of drawings that say something about you, or simply give yourself permission to draw random things on a page together.

The great thing about these pages is that you can use whatever you want; you can combine sketches with paintings, even a landscape with a doodle. Your only goal is to eventually fill the empty space with things.

For now, after drawing these scissors, see what other stationery items you can draw. Scour the desk around you or the space you're in and see if there's anything that would be interesting to draw, a collection of items that capture where you are right now. If you're in front of the TV, draw the remote. Have your phone by you? Draw it! What about a drink or snack you're having?

Fill the page with as many items as you can fit or however many you have time for. Challenge yourself with items of different textures, such as glossy or rough. And, as you practice your sketching and shading skills, see if you can learn a little more from each item you draw.

IN MY SKETCHBOOK

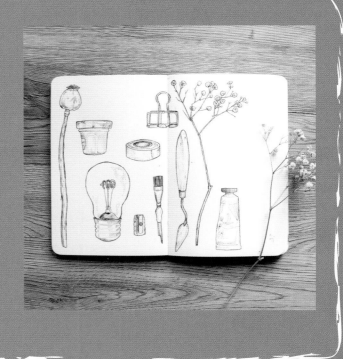

I drew the things around me on my desk and in my studio: a decorative lightbulb lamp, some dried flowers, stationery and painting tools and a little jam jar that I use to hold water if I'm painting on the go. To get the spacing right, I sketched everything in first with pencil before going over them with ink. I also started with the biggest items and then fit the smaller ones in around them.

Throughout the process, I learned that the longer I spend drawing, the less patient I am with the light touch required for shading with ballpoint pen. It's not uncommon to have your focus wane over the course of a long sketching session. Don't forget to take breaks, stay hydrated and remember that you can always come back to it another day if you find that you just can't seem to concentrate.

Day 8: Master Study

One of the best ways to hone a particular art skill or develop a certain style is to look at the work of admired artists. By dissecting their work and attempting to recreate and recapture what it is that makes it attractive to us, we offer ourselves a fun and interactive research session for which the pages of our sketchbook are perfect.

There are plenty of ways and reasons you might do a master study. You might be looking at the artist's technique or their use of a particular medium or color, the contrast in their pieces, the composition or a general mood that is conveyed or their style. You don't have to aim for an exact replica of their work, just a chance to really investigate the parts of their process that appeal to you. Focus in on those things and keep them in mind as you work; rather than just trying to copy their work, make an effort to deconstruct and understand it.

For our study today, we'll look at the famous painting *The Starry Night* by Vincent van Gogh. I chose this painting because I find it fascinating how Van Gogh made such effective use of his brushstrokes, especially when blending one color into another. It is a very impressive painting to look closely at, to see each individual brushstroke and then regard the painting as a whole, even squinting, to see how all that detail blends together.

We'll focus on one small part of the painting here: the moon, as I think it captures all the qualities of the painting that we'd like to study without presenting the overwhelming task of taking on a study of the painting in its entirety. In just a study of the moon alone, we'll get to look closely at the use of brushstrokes, the staggered blending technique and the use of flow with the direction of the lines. We'll bear all of those aspects in mind as we start our practice session for the day.

EXERCISE
Van Gogh's Painting Techniques in this *The Starry Night* Study

Supplies
- Blue Pencil
- Acrylic Paints: Yellow, White, Blue, Light Blue (which you can achieve by mixing White with Blue). Van Gogh used oil paints for this work, but feel free to use acrylics, or even colored pencils; just aim for something that will work well when layered. I used Acryla Gouache in Yellow, White and Prussian Blue
- Mixed Media Brush No. 4

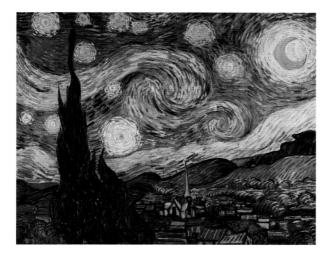

Let's start by looking closely at the image and, in particular, at the part we're going to paint. Can you start to pull apart the artist's potential process, the colors that he used, the potential stages he might have worked in, what order he went in?

When I looked closely, I saw that there appeared to be a yellow underpainting in the gaps that peek through from the blue background, so that will be something to remember as we start painting. Otherwise, it looks like the very lightest blue brushstrokes that separate the yellow section from the blue sky were the last to be painted. The size, length and width of each brushstroke also seem to be quite consistent throughout.

2

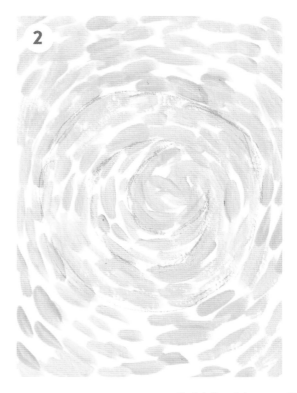

1. In the center of your page, draw a medium circle with the pencil. It doesn't have to be neat. And within that circle, draw the crescent moon.

2. Mix the Yellow paint with White to start that base layer. With short even brushstrokes and in a circular motion, color the whole background with the Light Yellow you made. Use this as a chance to figure out how much pressure you need to be using and how long or short you want the lines to be. You can fill the page entirely or leave gaps, as I have. The aim of this base layer is just to get some color down and get used to the painting process we'll be using as we go forward.

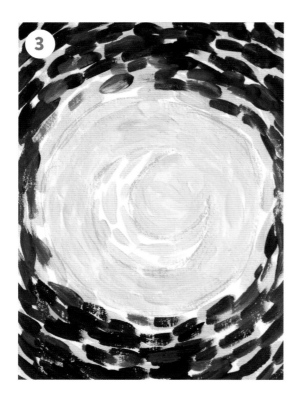

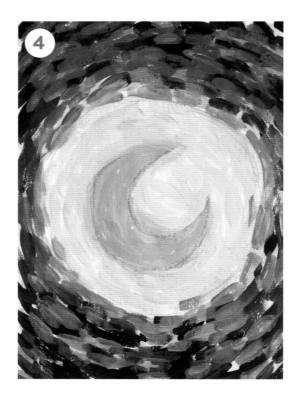

3. Now with Blue, in similar small brushstrokes, paint around the outside of the circle. I had Blue and White paint on my palette at this point and every time I dipped my brush to pick up more paint, I mixed a different balance of Blue and White to keep the background coloring varied between brushstrokes—but this is entirely optional. At the same time, add a bit more Yellow or more White to the background color, and fill in the rest of the circle around the moon in small strokes to maintain some of the texture there.

4. Use a Light Blue paint or mix of White with Blue paint, and fill in any gaps in the outer blue area with more short brushstrokes. Paint the moon in Yellow with the same technique.

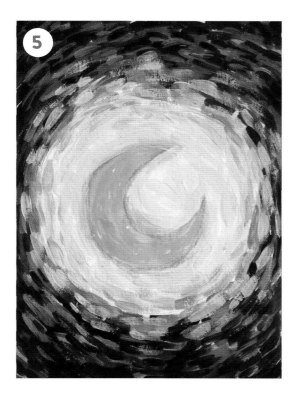

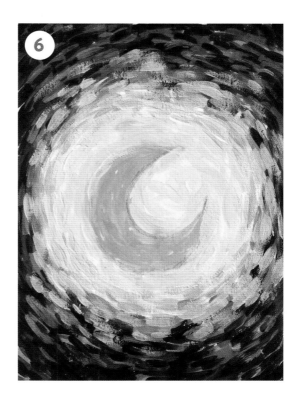

5. Now, go back to the darker Blue and use finer brushstrokes to add more texture and detail. Continue with these smaller brushstrokes all over, using a lighter shade of blue as you get closer to the moon.

6. Finally, mix the Yellow and Blue with White, and use this color on top of everything where the Blue border reaches the Yellow circle. Go back to the Light Yellow you mixed and paint it in short strokes around the edge of the middle circle. Remember to keep stopping to look at how the marks you are making are working as a whole. Are you achieving the gradient you want? Keep adding strokes of paint wherever necessary.

PROMPT
Explore the Style of an Artist You Admire by Repainting One of Their Works

Now that we know what we can do with a master study, our prompt for today will be to study the work of another artist we admire. Choose one of their pieces and focus on the parts of it that interest you the most. Remember to think about their process or the tools used, if that's what you're interested in. Look closely and get creative with the way you can capture that.

IN MY SKETCHBOOK

I chose Gustav Klimt's *Mada Primavesi 1912*, because the way he used blue in the shading around the face really stood out to me. As I was focusing more on color than technique, I decided to work in colored pencil to cut out the extra difficulties that come with mixing paint—I felt that pencils would still be able to get across the way the colors worked together, and I chose Cobalt Green, Dark Chrome Yellow, Deep Scarlet Red and Ivory for the job.

My initial light sketch of the girl's face didn't do a great job at capturing her likeness, but I chose to carry on regardless, as I was much more interested in looking at which colors were used where. The blue was most prominent to me, so I started by lightly shading all the areas where I saw blue—mainly the chin—and around the mouth and eyes. The next most prominent color to me was red, so I did the same with that, coloring the cheeks and the eyes, and layering the Red over the Blue, where necessary, to make a Dark Grey. Then I used Yellow to bring out the warmer areas around the forehead and neck. Finally, I covered everything with Ivory to fill in the blank spaces and blend things together.

I was less interested in the hair and background, so I used the same pencils and a Purple highlighter to finish those, and I swatched the pencils I used to remind myself of the effectiveness of the limited palette.

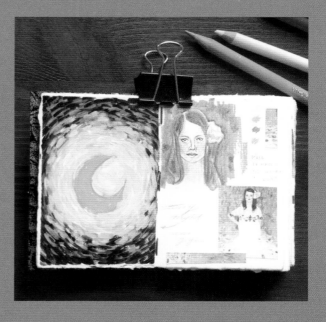

The discovery of how well Blue works as a prominent color in portraits, especially when used alongside Red, is something I'll hold onto in future work, and I'm now very eager to look deeper into Klimt's use of color.

Who knows how the things you stumble upon in your research of other artists will go on to improve and influence your art going forward? There is so much inspirational material out there waiting to be studied!

Day 9: Black Paper

There is something so exciting about the new dimension that working with black paper can add to your art. All of a sudden, you have the option to celebrate White and colors in ways you ordinarily wouldn't on white paper, capturing light and making the most of the contrast of colors against a dark background.

In The Blank Page exercise on page 10, you were asked to create a completely black page, either with black paper or a matte ink or paint on a sketchbook page. If you haven't done that yet, now is the time!

EXERCISE
Using Colored Pencils and Drawing a Bubble

Supplies
- Black Paper or paper colored Black with ink or paint
- Colored Pencils: White, Light Blue, Yellow and Pink. I used White, Light Pthalo Blue, Cadmium Yellow Lemon and Fuchsia
- Compass or Round Object: to draw a circle

Some colored pencils don't show up as well on black paper. If that's the case, you can work on any colored paper where you'll be able to see the White, or you can use something more opaque on your black paper, like paint or gel pens.

1. Draw the light White outline of a circle. If you don't have a compass, simply draw around a round object like a small bowl.

2. Around the inside of the circle, begin to lightly shade strips of White that follow the contour of the inner edge. Use differing pressure to increase and decrease how light or dark each strip of light is. Add a few small dots and a wider one at the bottom, to emulate a patch of light.

3. Use Light Blue around the inner edge of the bubble now. Shade lightly and build up pressure to make the color stand out more in some areas. You can also layer over the White pencil in some places.

4. Do the same now with the Yellow pencil in any obvious gaps. Continuing to follow the curve of the circle, bring the Yellow shading slightly closer to the middle of the bubble.

5. Use Pink in a similar way, slightly layering over some areas of Blue and Yellow, and sticking to the round shape of the bubble.

You can repeat this as often as you like. Experiment with different colors and different amounts of shading. The White outer edge against the black background and center creates a simple and effective base, and any mix of colors you add on top will almost always still result in a believable bubble.

PROMPT
Make the Most of the Unique Qualities of Black Paper with a White Pencil Drawing

On black paper, you can really take advantage of the negative space of the paper, allowing the page itself to be an integral part of the art you make. Use a White pencil or gel pen to draw something that celebrates the White highlights.

You could draw the light hitting the side of someone's face or a jellyfish deep in the ocean. What about a candle with a glowing flame? Or stars twinkling in a night sky?

IN MY SKETCHBOOK

I sketched the glass of water on my desk to see if I could capture the shine of the glass and the clarity of the water. As with the bubble drawing, once I had the White outline against the background and the main highlights in, I was able to add colors quite randomly around the edges and have it look like refracted light. I also noticed that, as well as casting a regular shadow, the light shining through the glass also left a sort of light-shadow on the desk, which was an interesting observation that I wouldn't have paid attention to otherwise.

EXPLORE POSSIBILITIES

*Delve into your strengths and interests in art,
and develop some more advanced skills*

With some solid and essential skills under our belts, now it's time to lean into our creative strengths in some more challenging exercises. We'll revisit color and hone our watercolor skills in a monochrome painting (page 91), dip our toes into the art of calligraphy (page 64) and test the observation skills we worked on in the first chapter with an advanced still life sketch (page 84).

Although our exercises are getting more advanced, it's important that we maintain the sense of confidence, ease and playfulness we carried with us throughout the previous sections. Remind yourself to go with the flow and embrace whatever you end up creating.

Day 10: Minimalism

We've looked at the benefits of simplifying our drawings and paintings to get a better idea of shape and form and value, and to loosen up and take the pressure off starting. Now we're going to explore a more challenging way of simplifying, by using a single line to create a drawing.

A continuous line drawing consists of one line that bends and curves to create the shape and some of the details of what we're trying to draw. These drawings can be incredibly complicated and detailed or strikingly minimal. Today, we're going to aim for a minimal look, which can be deceptively more difficult than its more detailed counterpart. While the drawings themselves look simple, it takes a lot of consideration to decide where you can put the fewest lines and still convey what you're trying to draw, where to start to prevent having to go back and forth too much, and how to get the drawing done in the fewest steps possible.

These drawings can be curved and flowing or angular. You can use varying line weights to add extra detail or keep your lines consistent. You can also choose to color these drawings after you're done. They can be a mindful practice—one that can be repeated often without too much effort—and they can make for some very compelling pieces of art. Let's try it ourselves with a drawing of a calla lily.

EXERCISE
Simplifying Shapes by Drawing a Calla Lily with a Single Line

Supplies
- Pen: I used a 1.0-cm Fineliner Pen

Try to keep your pen on the paper at all times throughout this exercise, flowing from one step to another. You can do it one step at a time as a practice or practice the steps in continuous motion with the lid on your pen, not putting ink on the page first. But, once you feel you have it figured out, try to let one step flow to another without lifting the pen.

1

2

3

4

5

1. Start toward the top of your page with a squiggly zigzag. You're starting this line at the bottom left-hand point and making the second peak half the size of the first, finishing to the right and slightly below where you started.

2. Continue from this point in a curved, wavy line that curves round to point to the bottom of the page. Use this line to close the open bottom ends of the initial zigzag.

3. At a downward diagonal from where you left off, draw another wavy line toward the center of the page.

4. This bit might be a bit complicated, so take it slowly. Draw upward from your last point in a short wobbly line that then loops around and down again through the underside of the petal.

5. Continue this line down to the bottom of the page, adding a slight curve if you'd like. Finish the bottom of the stem with a smaller diagonal downward line.

6

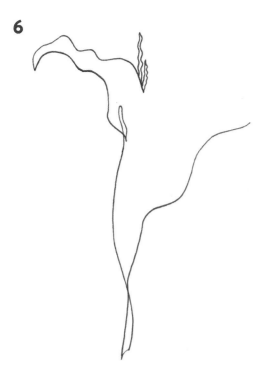

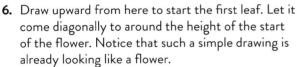

7

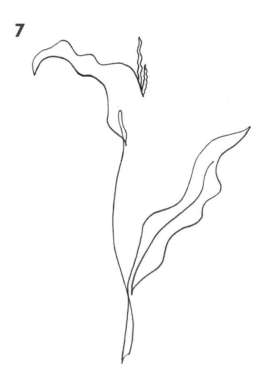

8

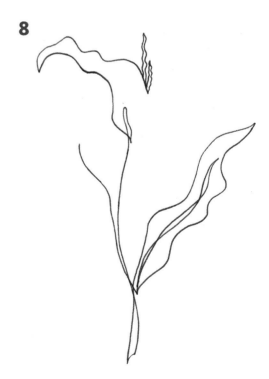

6. Draw upward from here to start the first leaf. Let it come diagonally to around the height of the start of the flower. Notice that such a simple drawing is already looking like a flower.

 You could stop here if you wanted to keep it really minimal, which is something to keep in mind for your future minimal drawings. You might have a plan for how you will make it look like the thing you're drawing but always pay attention along the way to see if you've already gotten the message across in fewer steps.

7. Draw the under edge of the leaf in a similar wavy line back toward the stem, then draw up the middle of the leaf with another wavy line.

8. Bring that middle line back down to where the leaf started and then angle it upward, across the stem to start the next leaf. Bring this one closer to the stem and around the same height as the top of the other leaf.

9

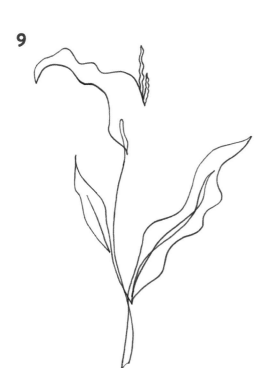

10

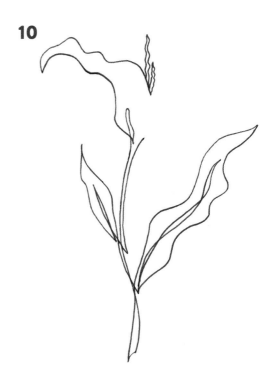

11

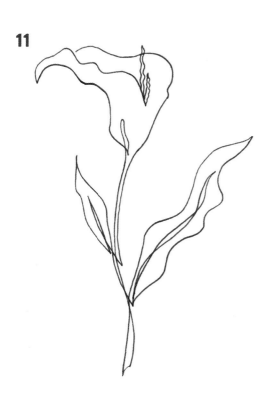

9. Follow a similar technique with this leaf, going down and then up through the middle to form its simple shape. This leaf can be much smaller than the first.

10. From the top middle of the leaf, draw a line down through the middle and through the stem, and then draw upward along the edge of the stem to finish the stem and go back to the flower.

11. Curve the line at an almost right angle until it reaches the first petal.

12. Finally, bring that line back in a similar curved right angle along the inside of the second petal. Let it join where the first petal meets the stamen, and end the line just before the start of the stem.

It is a back-and-forth game, a very thoughtful and considered approach. You might want to try again now that you're warmed up. You might be able to get it smoother, or you might have an idea of how you'd like to change certain aspects or simplify the drawing even more.

PROMPT
Create Your Own Minimal Drawing of a Flower

On the next page, draw another minimal flower. For an extra challenge, you could try drawing a face or an animal like a deer or swan.

12

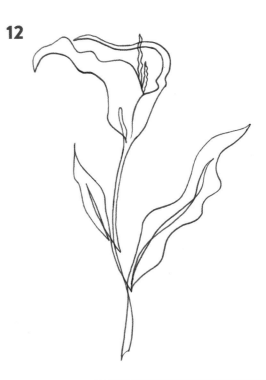

IN MY SKETCHBOOK

For my drawing, I chose a pair of poppies. I started at the center of the open poppy and made its shape with concentric curved lines spiraling outward, down the stem, which I branched off halfway to start the other stem. The closed poppy was more back and forth in loose zigzag lines, finishing back where the two stems meet.

Keeping it simple was a challenge, as there's always the temptation to keep going back and forth to add more detail and make clearer what you're trying to get across, but there's nothing to stop you from trying again and attempting to reduce the number of lines you use each time.

Day 11: Words

Turning words into art and incorporating words into your art is another different way to fill your sketchbook. Remember, a sketchbook is a collection of more than just drawings and paintings; it can be full of notes, stories, quotes and more. Finding a way to have fun with the words you put in your sketchbook is the next thing we'll work on. First, we'll practice a quick cheat for the calligraphy look.

EXERCISE
The Basics of Calligraphy with This Writing Exercise

Supplies
- **Graphite Pencil**
- **Ruler**
- **Pen**
- **Eraser**

You don't need a fancy fountain pen or brush to achieve dimensional lettering. Let's learn how to give any letters an artistic appearance. For this exercise, I chose to embellish the word "lovely."

1

1. Start with a grid of four parallel pencil lines. I have drawn them quite heavily here, so you can see them. Keep your marks as light as you can; you'll be erasing them later. Have the two middle lines closer together and the ones above and below a little bit farther away. You don't need to be exact, but if you'd like a bit more guidance, mine measured 0.8 inch (2 cm) from the top line down, 0.6 inch (1.5 cm) and then 0.8 inch (2 cm) again at the bottom.

2. Draw a diagonal line to the left of the grid. Again, it doesn't have to follow any rules, but as we begin, you may find it easier to have it tilt more vertically than horizontally; this will dictate how slanted your lettering will be. You can even choose to have the line go straight up if you'd prefer the words to not be angled at all. When you have finished the tilted line, place marks at equidistant intervals from the top point of the line and the bottom point of the line along the top and bottom horizontal lines. I chose to space these at 0.8 inch (2 cm) which is the same distance as that between the two center lines.

3. Now match up the points on the top and bottom lines to give yourself a diagonal grid like this.

4. Start your first letter from the center of the left-most square and draw a line that arches up through the upper middle line and curves to the top grid point. You can go straight in with pen, or practice first with pencil and then go over the top with pen when you're happy with your line. For this exercise, we want all of our letters to have their midpoint on the cross of the line, for the body of all the letters to fit within the middle boxes, and any sticks and tails to touch the top and bottom lines.

5. Curve that line back down to the bottom middle line, doing your best to follow the angle of the diagonal lines you've drawn. This is the end of the L and the start of the O, so go back up to the cross point for the top center of the O.

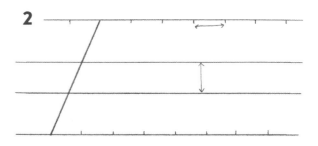

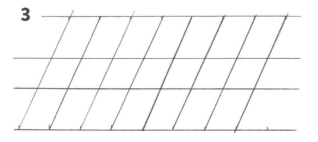

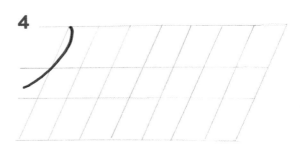

6

7

8

9

10

11

6. Curve the O around, again following the diagonal angle of the line up to the top.

7. Draw a V that has its center point on the next vertical line.

8. From the V, curve a line around to form an E.

9. Follow a similar technique for the second L. Try to get the curve and angle of this L as well as the gap in the loop the same as the first L.

10. Draw the start of your Y similar to the V, with its tail going down to the bottom line following the angle of the diagonal line.

11. Curl the tail of the Y around in any angle that you like. You can even add a swirl or some other flourish here, if you like.

12. Now look at each point where your pen traveled in a downward direction as you were drawing. These are the lines we'll thicken for the calligraphy look. If you're not sure where your pen was going downward, then—without touching your pen to the page—mime the action of writing the word again, hovering over the actual letters and make a mental note of any time your hand is swooping down. If you wrote in pencil, go over it with the pen, then erase all of the pencil lines.

13. Now thicken the downward strokes using the same pen. Try to keep the thickness of these parts consistent across each letter.

> **TIP!** To practice the techniques of lettering, try warming up with a row of letters like this, getting used to the flow of your hand and keeping each letter equal distances apart. Also aim to keep the curves consistent, such as the bottoms of your letters and the curls of the tails.

PROMPT
Get Creative with an Illustrated Quote of Your Choice

With this word drawn, you've nailed the basics of writing decoratively. There are limitless styles to try, but to expand on what we've practiced today, start by trying again using the same grid with thinner letters that are farther apart or wider letters that end up closer together. Shift just off the guidelines, alternating above and below for a bounce letter look. Or change the tilt of your guidelines to see how that affects the letters. You can even try not tilting them at all. And if you're feeling really confident, try it without the guide at all.

Write a word or several! You can write an entire quote or just fill a page with random words in different styles. Look at different calligraphy styles and see if there are any others that you'd like to try drawing. Then, decorate the rest of your page with relevant doodles, a background color or pattern, or a nice illustration.

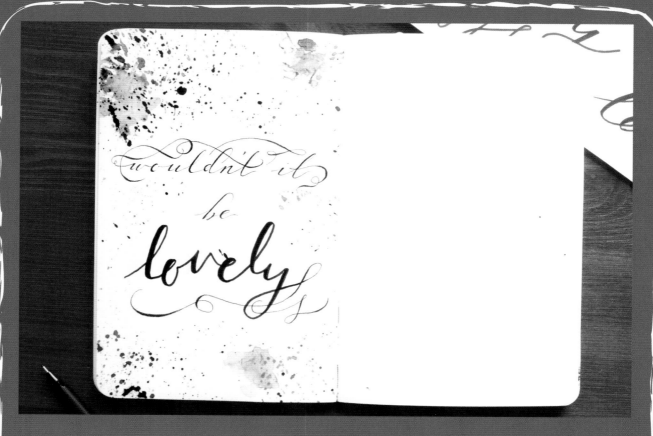

IN MY SKETCHBOOK

For my page, I combined the "lovely" I'd already written with the words "wouldn't it be." I tilted the guidelines more to give the letters more of a slanted look and wrote the words smaller with a larger space between the letters. I also used a finer pen for more of a fountain pen look. Instead of doodling or painting around my words, I decided to add the swirls as flourishes.

I started with a few simple ones and quickly got carried away. Adding flourishes is addictive, and I kept adding more! I just drew the swirly lines at random with pencil, seeing what worked and what didn't before committing with pen.

To fill the rest of the empty space, I covered the lettering with some scrap paper and used a paintbrush drenched in ink to flick splatters across the page. One drop did end up getting through to the E of "lovely," but I didn't let it bother me. While it would have been lovely for my words to be perfect, it was a lot of fun just going with the flow of the pen and then letting loose with the splattered ink.

Day 12: Collections II—Sketchdump

When we last explored the topic of Collections (page 44), we looked at using a sketchbook page to document a collection of items—a great go-to practice in observational drawing and a versatile way to fill sketchbook pages. This time around, we're using a similar concept with a bit more freedom and an added aspect of challenge, as we combine drawings into the appealing composition of a sketchdump.

"Sketchdump" is simply the term used to describe a collection of drawings combined on one page and often interacting with each other or appearing layered over each other. The sketches can be of the same thing at different angles, different facial expressions or with completely unrelated items, my favorite way to sketchdump.

Sketchdumping is a great way to get lots of ideas out at once, to vary the things you're drawing and to create a unique piece of art that spans a whole page. The variable nature of sketchdumping and the limitless options of things to draw makes sketchdumps a fun way to explore drawing different things, particularly in times where you're lacking inspiration. Just draw everything all together at once!

The great thing about sketchdumps is that you can draw or paint or combine mediums, and the choice is entirely yours when it comes to what you choose to include. If you do digital art, sketchdumps are a great way to compile random doodles and sketches, and turn them into a piece of art in their own right. And, as with the previous Collections exercise, if you tend to spend time scrolling through social media, sketchdumping is a great way to make the most of that time, stopping to draw any and all of the things that look interesting to you.

EXERCISE
Stylized Ballpoint Pen Sketches with the Start of This Sketchdump

Supplies
- Pencil (I used a red colored pencil, but any pencil will work fine)
- Black Ballpoint Pen
- Eraser

You can do this in whatever style you prefer. But one way to loosen up and fill a page without too much time spent is with a faster, more stylized sketch, so that's what we'll practice today with a strawberry and asparagus.

1. For the strawberry, start with a pencil sketch of a rounded triangle.

2. Add some thin curved triangles as leaves coming out of the top and a row of evenly spaced seeds curved along the top end of the strawberry.

3. Fill in the rest of the strawberry with more rows of seeds, with the seeds getting smaller the closer they get to the bottom.

4. Redraw all of these lines with the pen, and erase your pencil lines.

5. Unlike our previous ballpoint pen sketch, we'll speed up the shading process by eliminating the time needed to work on subtle blending. Instead, lightly outline the area you'd like to shade first: a wobbly sliver down the right half of the strawberry.

6. Fill this section, reducing the pressure on the pen to achieve a Dark Grey shade. Leave the seeds white, and do the same for the base of the leaves.

> **TIP!** *When shading these outlined areas, use the same light strokes in one direction, as always, but start your shading at the edge and work your way in.*

7. Lightly shade the remaining right-hand edge of the strawberry and the rest of the leaves.

8. Outline a small area that you'll leave white as the highlight, then fill most of the rest of the space with a lighter shade of Grey. Don't worry too much about streaks in your shading, it's all part of the sketchy style.

9 **10**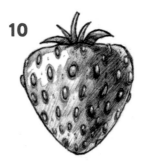

11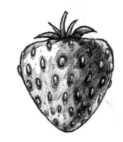

9. Shade around the seeds with light, spiraling circles.

10. Finish the strawberry with a few light dots around its surface, to add the impression of texture and more tiny seeds.

Now we'll dump another sketch in, playing off the sketch we already have so the whole thing can flow as one.

11. Draw a long rectangle at a slant behind the strawberry. This is a great way to place your next item in the sketchdump before committing to a detailed drawing that might not fit. Instead, block in the overall shape first to give you a guide.

12. Within that rectangle, draw two tapered sticks, one in front of the other.

12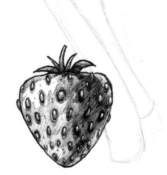

13 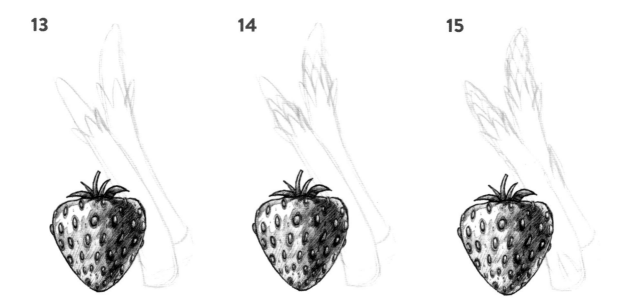 **14** **15**

16

13. Toward the top of these sticks, draw a row of three petal shapes.

14. Layer more of these petals in rows on top of each other.

15. Continue these to the top in small diamonds, and add a couple of leaves to the stalks of the asparagus.

16. Outline the sketch in pen and erase the pencil lines.

17

18

19

20

17. Lightly outline the central area of each spear of asparagus and—leaving the leaves white—shade that section in a Medium Grey.

18. Deepen the central part of this shadow and the area where the asparagus touches the strawberry. This helps create a sense of the two objects interacting on the page.

19. Lightly shade the white areas of the spears, then shade each petal from the base upward, following their shape and deepening the shadow toward the bottom.

20. Finish the other leaves in a similar way, just leaving a small area of white where the leaf meets the stalk.

PROMPT
Finish the Sketchdump with More Layered Fruits and Vegetables

This way of sketching is a great stylized shortcut to effectively shaded objects. Continue this sketchdump with more simply shaded fruits and vegetables layered over and around each other.

IN MY SKETCHBOOK

Rather than drawing one object at a time, I sketched all the rest of the food at once to achieve a composition that fit well on the page before committing to ink. In spaces that felt like they were missing something where I wasn't sure what to draw, I filled in the gap with a shape that I felt would work well there. That shape could then be turned into something later. For example, the tomato started as a circle in a gap that looked like it needed filling. And if you can't think of something to fit, you can shade in the shape and make it part of the design, like I did with the red square behind the cherries.

Remember, you can always use blocks of color, boxes, shapes and shading to fill awkward gaps and bring attention to particular things, as something with a colored background will stand out more than the rest of the items on a white page.

Day 13: Thumbnailing

A thumbnail sketch refers to a small drawing typically used to plan a larger piece. Working in a small and rough format allows you to map out the key shapes and values in a piece before committing to the real thing. It is also a great way to capture an image quickly without needing to focus on the details.

You can also use thumbnailing to quickly sketch out different options for one particular piece to figure out which layout will work best. Thumbnailing is a pressure-free way to explore ideas without committing to a larger piece. The technique also allows you to quickly get an image from your mind onto paper.

A thumbnail can be a simple line drawing or it can include shading; it really depends on how much information you'd benefit from having planned out. Generally, pencil is used, but you can also use pen to really hone in on the most basic of shading and to stop yourself from getting too caught up in detail. Thumbnails are created so quickly and simply that any mistakes can quickly be moved on from in the next attempt, and the next and the next. . . .

Working on such a small scale forces us to make the most obvious statement and communicate what we're trying to draw in the easiest and clearest way. Similar to what we learned in the Gesture Drawing (page 38) exercise and even the Timed Challenge (page 23), this lends itself to looser, more dynamic drawings, when the idea is eventually scaled up or detail is added, rather than a more meticulous approach, where a focus on detail from the beginning can result in the final work looking stiff.

Let's practice by creating a thumbnail sketch of this beautiful landscape, *Argenteuil,* by Claude Monet. But before we start, take a moment to simply look at it. Squint and see how much you can simplify the composition in your mind. If you could draw this with only three colors, light, medium and dark, how would you do that?

I would have the sky and water the same color, the distant land and houses, and strips of light in the foreground in a medium shade and the majority of the foreground in the darkest shade.

And what if you could only split this into a handful of outlined shapes? The trees would become one element, the land in the foreground another and the land in the background its own simple shape, flanked by the water and sky.

This is how simple you can get with thumbnail drawings. If you're trying to do quick-fire sketches to get an idea out on paper, this is a great way to do it.

EXERCISE
Seeing Key Values and Shapes by Drawing This Miniature of a Famous Painting

Supplies
- Pencil No. 2B

For our practice exercise, we'll add a tiny bit more detail. A certain level of detail is useful for making sure the idea will translate well when it's scaled up.

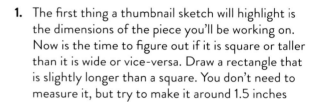

1. The first thing a thumbnail sketch will highlight is the dimensions of the piece you'll be working on. Now is the time to figure out if it is square or taller than it is wide or vice-versa. Draw a rectangle that is slightly longer than a square. You don't need to measure it, but try to make it around 1.5 inches (4 cm) tall.

2. Let's look at where the horizon lies. Draw a line just under a third of the way up your box.

3. Now, shade a small wedge in the left-hand half of the horizon to form the background land. If possible, leave a small sliver of white as the sail of the boat there. Don't worry if you're working too small for that kind of detail, we really just want the most essential information. Shade this in a medium tone, one that can easily be made lighter or darker, if necessary.

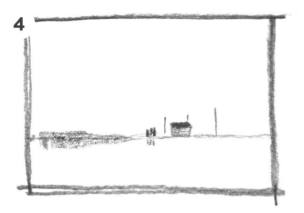

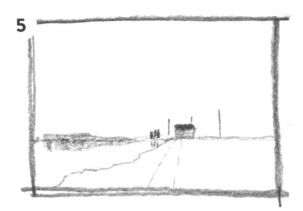

4. Still along the horizon line, shade a small box in the same color for the house, just right of the center. With a bit more pressure, shade in a few darker trees in the center. Add the dark roof and add some thin lines for the chimneys in the background. Notice how we don't need to get the exact shape of the chimneys or the details like windows on the building in order for it to still read as a building or for the chimney to still contribute to the overall composition.

5. From the center of the page draw a wobbly line out diagonally to the bottom of the box and two more following the perspective of the road, to split the bottom center of the page in half.

6. Shade in the shrubbery at the water's edge with your darkest shade, and then use a medium shade for the rest of the grass on the shoreline. Leave a few small strips of white where the light from behind the trees is streaming through.

7. Color the rest of the foreground in this dark-medium tone, continuing to leave gaps of light where you see them. Darken the ground where there is grass along the road.

8. Shade in the small dark details in the background, and add the tree trunks and the start of the tree in the top right corner.

> **TIP!** *Your shading can be very random. For leaves and shrubbery, little zigzags in different directions are more than effective. For flat surface areas, zigzags or lines in one direction will work well, too.*

9. Finish off the trees and very lightly shade the top of the sky and the lower edge of the water. Just a few light lines placed farther away from each other are enough to suggest the gradient of shading.

From this kind of sketch, you would be able to break down what started as a complicated painting into more of an achievable project to tackle with a better understanding of what goes where and how each element compares and contrasts with the others.

PROMPT
Practice Thumbnails by Drawing Scenes from a Film You Love

I hope that through this exercise you've discovered how quick and easy it can be to simply get something down on paper and give all of your ideas a chance to exist outside of your head. Overwhelming concepts can be broken down into simple shapes and shades as a more approachable starting point. And, this can be used to understand more about composition, and what will and won't communicate your ideas effectively.

To explore that idea further, let's use what we've learned and try to simplify some more images into thumbnails to get an idea of the basic elements that make up a satisfying and effective composition. A great way to do this is to look at film screenshots—these are still photos from films that have already been thought through and planned. Like in painting, film language communicates different ideas and feelings, and gives the viewer a certain impression just by how things are placed, how they are lighted and how contrast is used. Since the filmmaker has done the work for you in terms of putting together a pleasing composition, this is a great way to get a better understanding of effectively balanced scenes.

You can also do this with additional existing paintings or even pictures in magazines or on social media. Seek out images you find satisfying to look at or think of your favorite film, find screenshots and draw them in thumbnails, taking some time to think about the key elements and how things have been thoughtfully laid out.

IN MY SKETCHBOOK

I chose to thumbnail a portrait painting by Raphael, in which the lighting expertly highlighted the subject's face. I also looked at the classic film *Nosferatu*, which makes the most of shadows and framing so that each scene appears to be very well-considered.

Trying not to get too detailed is a challenge in itself; I find it easier to keep it simple when I use a blunt pencil for thumbnails. Not having a fine point to be able to add small details means I must try to work on just getting the key shapes down. Using a pen would also help if you're struggling to loosen up and stay away from details.

Have fun, work quickly and draw several of these little vignettes over and over until your page is full.

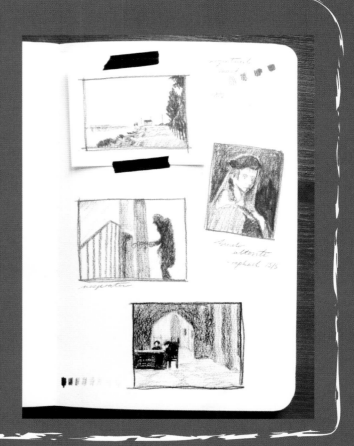

Day 14: Repeated Patterns

So far in our exploration of patterns, we have discovered how to use the elements of dot, line and shape, and the many variations and combinations they hold. We also looked on Day 4 (page 28) at using color palettes in abstract geometric patterns. Now, we'll look at more intricate, repeated patterns.

These can be a fun way to practice painting a particular thing or repeating a newly learned technique—for example, instead of simply drawing something over and over again to get familiar with it, we make a pattern out of that practice and are able to see our improvements in one place as a piece of art in its own right. Repeated patterns are also a lovely way to adorn blank space on pages and, if nothing else, as with our other pattern practice, they can be a totally mesmerizing and meditative creative exercise.

Most repeated patterns follow some kind of grid format. The grid itself isn't always clear, as objects may intersect the border lines, but here are a few examples of this:

Grid

Offset Grid

Diamond

With that, let's create a pattern of our own.

EXERCISE
Fun Watercolor Brush Techniques and Painting a Page of Leaves

Supplies
- Round Watercolor Brush No. 8
- Single Watercolor Paint Color
- Pencil (I used a graphite pencil but any pencil will work fine)
- Ruler

Before we begin, we'll practice some brushstrokes. A round brush works great for this, because it can be used at a fine point and you can also thicken out your paint stroke considerably. Paint some leaf shapes like these, going from top to bottom, with a very light touch, pressing the belly of the brush down into the page as you go and then easing up on the pressure again at the end. Do this repeatedly, both up and down, until you start to get the hang of it. Also, try to get the finest lines you can with the brush.

1

2

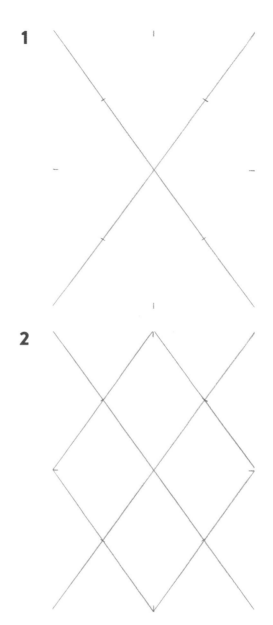

1. Now, with the pencil and the ruler, very lightly draw a line from one corner of the page to the opposite diagonal corner and, do the same for the other side. Mark the midpoint between the center (where the lines intersect) and each corner. Also mark the midpoint of each edge.

2. Join the dots so that you have a grid like this.

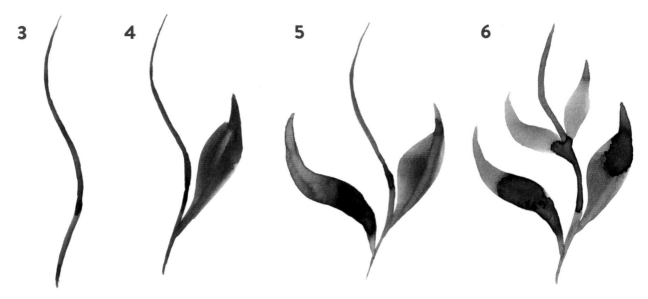

3. Now, in one of the diamond sections, draw a thin curved line from the top to the bottom.

4. Paint a leaf like the ones we practiced that joins the bottom right of the line.

5. Do the same again on the left.

6. Add another pair of leaves halfway up the line.

7. Now, add 2 smaller leaves toward the top.

8. While the paint is still wet, you might want to go back over certain areas to darken them with more paint. I like to darken the underside of each leaf, but this step is optional.

Now, simply repeat these steps in each of the sections, taking care to get each one as similar to its neighbor and making an effort to practice those brushstrokes throughout. Continue until the page is full.

PROMPT
Create a Repeated Pattern with Another Watercolor Brush Design

These simple brushstrokes are so effective and so fun to use. Letting the paint flow can be such a calming experience, and the repetitive nature of the pattern exercise is also really comforting.

You might like experimenting with different-shaped leaves or flowers like these.

To use what we've learned about brushstrokes and patterns, choose one of the grid layouts we looked at earlier, and fill it with a repeated pattern that uses a brush technique like this. If you don't want to paint flowers or leaves, how about a bird? I can imagine a swan being effective in this style. Or how about a random swirly pattern?

Let yourself get lost in the repetition, and hone your watercolor brush skills in a fun and mesmerizing way.

IN MY SKETCHBOOK

I went with a random swirl approach for my pattern, choosing a lovely Blue color to invoke a porcelain look against the white of the page. I chose to use the same grid pattern as before and added a few tiles of the pattern on the adjoining page.

As with the leaf pattern, I started with a curved line through the middle and built out my shape from there with brushstrokes that varied in pressure. It was so hypnotic: I could honestly have done this all day!

Day 15: Observational Drawing

Put simply, observational drawing is just drawing what you see. That could be objects, landscapes, people or anything that is in front of you at the time. We've already touched on the importance of observation during our Drawing from Memory (page 33) exercise, and we learned that through the practice of observational drawing, you can develop your ability to translate what you see in front of you onto paper. This is useful in all aspects of making art, because when you have an accurate idea of how something looks, you gain a better sense of freedom and confidence to transform and stylize it.

> **TIP!** *Look at the thing you're drawing or painting more than you think you need to. As a challenge, try to look at the thing you're painting for the same amount of time as you look at your painting itself—if not longer! Your eyes should constantly be moving from your work to your subject. It's very easy for us to assume we know what something looks like and to miss out on small details that lead to differences between what you are painting and your painting.*

For today's practice drawing, we'll take on a challenging subject, something that will require a lot of concentration and a level of attention to angles and lengths of shapes, and how one part of the drawing relates to the other.

EXERCISE
Detailed Pencil Sketches with This Origami Crane

Supplies
- 2B Pencil
- Eraser

In our Drawing from Memory exercise, we took our first steps into the techniques of pencil drawing. Today, we're going to expand on that by attempting a bit more detail in our pencil drawings. If you don't feel ready for this, feel free to adopt the techniques from the previous pencil-sketching exercise. But I will do my best to guide you through the process of drawing and shading in detail with pencil.

First, let's get a sense of the object as a whole and simply look at it for a while. Try to take in as much detail as you can. Imagine we're about to try to draw this from memory. How much information can you take in? Try to bring this level of attention to every time you look at your reference.

1. This step will give you a sense of the scale of the item you're drawing as a whole and the key forms that will make up the drawing. To do this, draw a long diagonal line across the page at the angle of the wings, that is from the tip of one wing to the tip of the other. And—paying attention to perspective—find where the body of the crane intercepts those points.

2. We'll give ourselves a good foundation to work out from by drawing the body first. This will help us ground the rest of the drawing by giving us a reliable starting point. Rather than imagining where each fold of the paper lines up, simply look at the image as a series of intersecting shapes and lines at different angles. Pay attention to the length and angle of each line. In doing this, we end up with a slightly tilted triangle at that midpoint of the wing line, another triangle underneath and then, to form the other side of the torso, a similar angled line. I chose to join all the lines here despite some areas being behind the parts we can see; this just helps things line up and we can erase any excess lines later.

3. Next, draw the wings. The points of each wing will be at the tip of the initial diagonal line you drew, and the rest of the wing is a long, thin triangle that comes out from that and meets with the edges of the first triangle you drew, angling in toward the body. Notice that the wing in the back does not have 5 visible angles like the one in the front. If we weren't observing the reference, it would be easy to assume that that corner is visible, but due to the angle of the origami crane that detail is lost.

1

2

3

4

5

6

4. Finally, draw another long, thin triangle for the tail and a similar one for the neck and head. Pay attention to how far from the body the tail goes and how thin it is in relation to what you've drawn already. As always, think about the angles you're seeing and how each part connects to what you've already drawn.

 Now, erase any excess lines and lighten up your outline, if necessary, with your eraser. For a more realistic look, we aren't aiming for heavy outlines.

5. Start shading with the lightest area you see. However that shade turns out will be the starting point that you will get progressively darker from across the rest of the drawing. With the lightest touch you can manage, shade in the back wing. Have a look at the reference. You can see that this wing as a whole is lighter than the rest, but can you see where the light on the wing varies? I think the left-hand side of the crease in the wing is slightly darker, so—still with the lightest touch—add another light layer of shading over what you've already done. Do this for any other areas where you can see variation in the shade. The key is to start with a very light shading and very, very gradually add layers to darken particular areas.

6. Now that we have the lightest area out of the way, let's try something a bit darker. That way, for the rest of the shading, we'll have a good scale to measure how light or how dark we should be shading in relation to the lightest and darkest areas on the page.

 As with before, start with a flat shade over all shaded areas. Don't be tempted to press too hard with your pencil. Continue to build up light layers until you're happy with how dark things are. I left areas of white where there are highlights as well. You don't have to do this, or you can use the eraser to carve them out when you're done.

7

8

9a

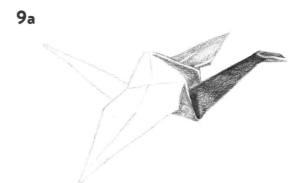

9b

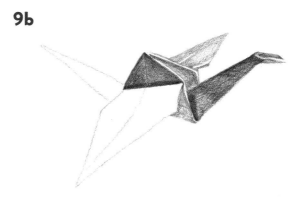

7. Again, continue to deepen the shadow in areas where you can see variation. I think the shadow gets deeper toward the top of the crane's head and along the back of its neck. There are also slight ripples in the paper that can be gently colored in. I also deepened some of the shadow on the wing at this point. Don't be afraid to revisit areas of the drawing that you've already worked on as your work develops and new details become apparent. You'll probably find that necessary in order to make sure the whole drawing comes together rather than seeming like lots of separate sections next to each other.

8. Now we're free to shade in whatever order we like, but continue to go one section at a time, always comparing and contrasting the shade of the new area to the places you've already done. I felt that the inside of the torso was a middle shade between the wing and the neck. I also noticed that it was darker toward the top, which you wouldn't expect—I would have imagined the shadow getting deeper as we got farther into that valley of the body, but it looks like some light is reflecting from the inside of the other side. This is another reminder to not assume we know what something will look like and to always refer to the reference before making any decisions.

9. The rest of the body of the crane is shaded in this manner, with the main portion being the darkest part of the whole drawing (9a) and particularly dark where the wing meets the body (9b). I even lightly added a line where there is a crease.

10

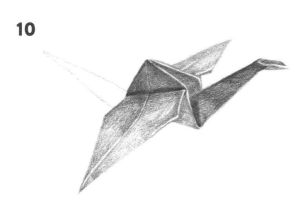

11

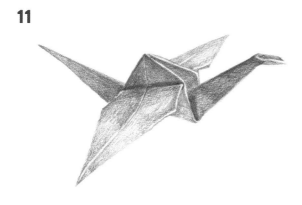

12

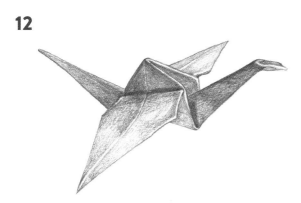

10. Shade the other wing in the same way. At this point, I again revised an earlier area by deepening the shadow of the inside of the body to help it fit better with the rest, as the darker portion of the body was a huge contrast.

11. The tail was quite simple, that same-medium dark tone as in Step 6, with a little bit more shadow toward the body.

12. The last step is to neaten up the edges. Sharpen your pencil and lightly draw around any of the edges that appear smudged or feathered. As always, use a light touch and add pressure only where necessary.

That was quite an intense practice. Maintaining concentration and observation, and battling the habit of simply drawing based on what we think we know is a constant effort. You're free to leave today's practice there, but if you'd like to expand on what we've learned and really test your observation skills, let's work on a still life drawing.

PROMPT
Practice Drawing What You See by Drawing a Still Life

Still life drawings and paintings are a great way to work on observation. In the context of a still life, the focus of your observational drawing will be on drawing inanimate objects, as still lifes usually depict an arrangement of items. They could be meaningful objects that carry certain symbolism or themes, or objects chosen to represent a certain time—to capture a fleeting moment. Still lifes could also contain objects with no real story or symbolism behind them, things that just look nice or something that the artist was particularly interested in studying.

The choice of items, the way they are arranged, the composition of the drawing itself and the way the arrangement has been lit are all creative ways to make a simple collection of objects stand out and tell several unique stories. And the bonus is that, along the way, you will undoubtedly be building the skills of observation that will come in handy for anything else you go on to create in the future.

It's easy to set up your own still life arrangement. Grab some fruit, some fabric and some plants from around your home. Pick up objects that catch your eye, trinkets and things you feel represent you and your interests. Try to find things of different sizes and textures, and group them together in a way that allows you to see a bit of everything. To begin with, you might just want to start with three or four items, so you're not overwhelming the composition and creating something that's overly busy to look at or complicated to draw.

You can work with natural light, or you may want to have fun with lamps or torches to create some interesting shadows. Also bear in mind the angle from which you'll be drawing your still life. Position the items at eye-level for a more traditional still life, or experiment with angles by looking down on your arrangement and seeing how that affects the shapes and perspective.

Either draw your arrangement from life or, if you find it easier, take a photo and draw from that. Just remember to pay attention throughout to the nuances of each shape and shade. Don't assume you know how things look—try to see what you're drawing not as objects, such as "apple," "book" or "plant," but as a collection of shapes that are relating to each other in different ways.

If you're unable to put together a still life composition of your own, here's a photo I've taken that you can work from.

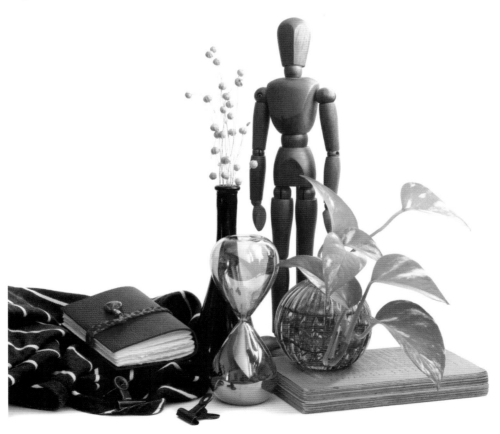

IN MY SKETCHBOOK

Before starting, I took a moment to look at the composition as a whole, even squinting to get an idea of the basic shapes and structure without any detail to distract from the most important information. I looked at the height of the overall composition compared to the width and eventually started to see a sort of triangle within which were the main objects. I very lightly drew the triangle, the tip being the head of the mannequin, with the corner edges of each book forming the base.

With my initial sketch, I started with the mannequin, as it was the most impactful part of the composition, and I felt everything else could be determined through the size and placement of that. Initially, I drew it too big, so I was forced to erase the whole thing and start again.

> **TIP!** *When you are erasing a sketch, leave some of your initial sketch behind. You can use what's left from the original as a marker to let you know what changes need to be made for your next round of sketching. This is learning from your mistakes in its most literal form, essentially using your mistakes as a guide to more easily learn the right way to do it.*

Next, I started to look at the curve of the vase and the size of it in relation to the mannequin, where those objects met and at what angles the outlines of them related to each other. It was very useful at this stage to pay attention to the negative space between the objects rather than the objects themselves. This gave a clear sense of the angles involved, rather than getting caught up in trying to draw one object and then another.

I continued to sketch in this way, moving from one part of the drawing to another and using the previous parts of the drawing as a constant guide for where things should go and what size they should be. Finally, I moved onto shading. The key with the shading throughout was to maintain a very light touch and build each layer as was necessary as the drawing went on, deepening shadows when the neighboring contrast wasn't enough.

There were many moments throughout the process where things didn't look quite right to me, but I tried not to dwell on that, as the purpose of this practice was not to draw something perfect, but to practice observing. Don't be disheartened if your own work isn't looking how you want it to—recognizing the differences in what you see and what you're drawing is a skill in itself and an invaluable step in the right direction.

Be a keen observer and problem-solver, recognize the differences and learn from them and always try to continue to hone your skills of observation.

Day 16: Monochrome Painting

As we first discovered in the color palette exercise (page 28), a monochrome painting is one in which you use a single color in varying shades. On top of being visually striking or capturing a certain mood or temperature, these types of paintings can also be a fantastic way to familiarize yourself with value; that is, how light or dark something is.

Use of color in artwork can be an impactful means of expression, but some people find that having all the colors in the world at their disposal can make it easy to lose sight of the nuances of shadow and light, and what those subtle changes can do to the atmosphere and depth of their painting. Regardless of your relationship with color in your work, it can be so valuable to try stripping your palette down to use just one color as a chance to focus solely on recognizing those shifts in tone and the gradation from light to dark. Through practice like this, you might notice in your landscape paintings, for example, how the farther into the background you go, the lighter things get. Or you'll see that those darkest Blacks you thought you saw in the eyes of the portrait you were looking to paint, actually pale in comparison to the darkness and depth found in the surrounding eyelashes.

Additionally, if you're not entirely confident with your use of color yet, then monochrome paintings can take the pressure off getting that element of your work right. Once you have an understanding of value and how the shifts from darkness to light can suggest form and depth, you'll see that you've already done most of the hard work. Regardless of the colors you use, even if your painting is made up of mismatched and clashing patches of lots of different colors, you can still capture the form of whatever you're painting if your colors have the right value.

EXERCISE
Layering and Shading with Watercolor by Painting a Waterfall Scene

Supplies
- Light Blue Pencil
- Watercolor Brush No. 4
- Single Blue Watercolor or another color of your choice

We're going to paint a mountainous waterfall scene using just one blue paint.

1

2

1. With the pencil, draw a straight line along the bottom quarter of your page and three rows of angled lines through the middle of the remaining space.

2. Add a small round circle to the sky and two lines downward from the lowest point of each of the angled lines to the next, increasing the space between them as you get closer to the foreground. Finish this step with a wobbly line to mark the edge of the land and a wobbly circle as the reflection of the moon.

3

3. Add some rough-edged shapes here for the trees in the foreground at each side of the page.

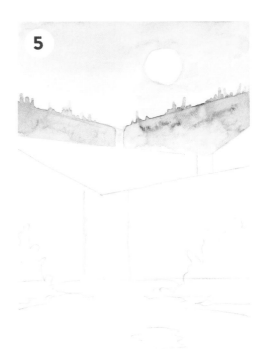

4. Mix a very light shade of Blue and use it to color in the sky, leaving the moon white. Add more water to your mix to make the paint color lighter as it gets closer to the horizon.

5. When this layer is dry, paint the farthest section of land with a slightly darker—but still very light—Blue, leaving the waterfall white. Paint some rough lines along the top edge for some distant trees and very lightly shade the top of the waterfall. Again, you can add more water toward the bottom of this section to add a gradually lightening gradient.

TIP! *If your paint is going on too dark, wash off your brush, squeeze the excess water out with a paper towel or rag, and use the dryish brush to reabsorb and pick up some of the paint you've just laid down.*

6. Mix your Blue paint with slightly less water, and re-peat the previous steps on the next section of land. You can add a little more detail to the trees here and continue to make each section lighter toward the bottom.

7

8

9

7. Darken your Blue again, and repeat the previous steps on this section of land. Remember not to cover the waterfall behind when you paint the trees.

8. Leave the foreground trees clear for now, and move on to the shoreline. Paint it in the same Medium Blue as the most recent section of land.

9. With a lighter mix of Blue, paint the water, remembering to leave the reflection of the moon and the area closest to the shore white. You can work in horizontal strokes and layer the paint here while it's still wet, to create a sense of ripples in the water.

10. When everything is dry, paint in the foreground trees with the darkest shade of Blue.

You can add another layer to your foreground trees to darken them even more.

PROMPT
Explore Value with Your Own Monochrome Painting

Now that you know how well a single color can convey depth in a painting, it's time to see what else you can do with a monochrome palette. It's up to you what art supplies you use for a monochromatic painting.

If using watercolor, you can simply choose one color and use varying amounts of water to dilute the paint and adjust its lightness. This is also a great opportunity to experiment with the consistency of your watercolor paints and the amount of water needed to achieve the tone you're looking for.

For paints like acrylic, oil or gouache, you would use a single color again, but you would lighten the color with White paint instead of water, and you can explore how much—or how little—White paint is needed to noticeably alter the lightness of your chosen color.

TIP! *Try to make your base color something darker, like a Prussian Blue or Burnt Sienna. That way, you're giving yourself lots of room to explore the lightest and darkest shades of whatever you're painting.*

You may even want to use colored pencils or markers. For colored pencils, using a very light touch will result in the lightest shades, and layering more color on top

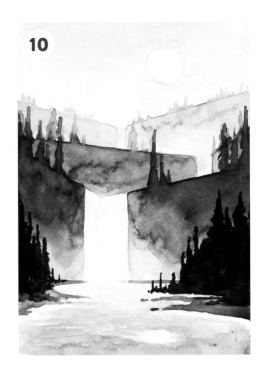

10

or using a heavier hand will garner darker tones. If using markers, you may need a few different markers that are different shades of the same color.

Your approach with these paintings is entirely up to you. But I do find that working from the lightest areas to the darkest—especially when using a medium with which you would traditionally build layers, like watercolor or colored pencil—can help the process unfold a lot more smoothly.

This might also be a great opportunity for you to try a tiling painting technique, which is essentially like paint-by-numbers but without the guides. This works best with your more opaque paints, like gouache or acrylics, and we'll look at this technique in more detail in the penultimate exercise (page 160) in the book. But essentially, here you would choose your starting color—I usually work from dark to light—and lay down any areas that are that color. Continue to do this, gradually mixing more White into your paint and blending your tiles into one another as you go, until you're filling in the very highlights of your painting.

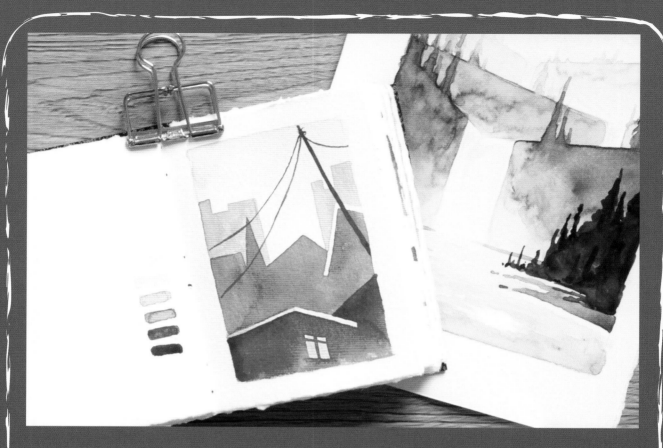

IN MY SKETCHBOOK

I used Quinacridone Magenta watercolor paint for my monochrome painting. It's one of my favorite paint colors, so being able to use it alone felt like a true celebration of the color. I swatched it first to get an idea of the range of shades achievable and then, with a Red pencil, I sketched in some geometric shapes to form layers of buildings working their way back into the distance.

When it came to painting, I started with the top of the sky, in the lightest mix I could manage. Then, I added water to my brush and blended the color out as I got closer to the first buildings. I used varying concentrations of paint and water to fill in the buildings, getting darker as they got closer to the foreground. I also added an extra feature by leaving some roofs and a window clear. Finally, I used the darkest color to paint an electrical line across the page. This was a fun and simple practice, and definitely something I will do again.

How could different colors change the ideas you come up with? Using Yellow, you could paint sand dunes. Or how about Green forests, Grey cityscapes, Blue waves? How many other things can you think of? The options with monochrome paintings are limitless.

GET CREATIVE

Generate endless ideas and develop a skill for imagination, innovation and out-of-the-box thinking

We're creating confidently and fluidly now, with a greater understanding of some of the most fundamental art skills. With the new knowledge and self-assuredness these skills have brought us, we can start to push ourselves outside the box, generating new and unique ideas that we now feel much more capable of realizing.

In this section, we will come up with imaginative ideas in a commission-style project (page 124) and a color challenge (page 130), we'll test new styles and techniques with ink and watercolor (pages 99 and 115) and we'll learn to make the most of the endless options available to us when blending one color with another (page 109).

This portion of the sketchbook project is the most daring so far. I hope you're ready to generate some exciting ideas and try things that you may never have tried before.

Day 17: Travel Journal

At the very start of this project, we touched on some beginner journaling techniques by exploring the different elements that go into building a satisfying spread (page 17): namely writing, photos, doodles, drawings or paintings, larger text, like quotes or headings, boxes and blocks of color or texture and collage. Now, we're going to revisit what we learned there with more of an emphasis on the drawings and paintings that are involved.

Travel journaling is a great way to capture the memories and souvenirs of trips you've taken, or even the ones you want to take in the future. You can bring your journal with you and add art and mementos as you enjoy your holiday, or you can save all the memories, trinkets and photos, and create a record of it all when you get back. You can choose to make the journal writing-focused, as you document the things you did, the places you visited, sights seen, people met and the foods and customs you experienced. Or, you can choose to capture the memories in a scrapbook of photos and receipts and tickets. You can also communicate those memories through drawings and paintings of all of the above. And, of course, you can combine all of these things to create a travel journal.

Quite often, a specific sketchbook will be chosen to act entirely as a travel journal—possibly even just for one trip, with every page filled with the story of a particular journey in one themed book. However, there's nothing to say that you can't take that same concept and use a single page or a handful of pages in your sketchbook to record the highlights of a vacation, a short trip or even a single day. It doesn't even have to be about a holiday; you might want to journal about a trip to a museum or a day you spent visiting a relative, even a short outing to your local garden center, library or coffee shop.

Glue, a Fineliner Pen and watercolor paints can make up the simplest travel journal kit, and you can build on it from there. With these simple tools, you'll be able to do your writing, sketching and painting, as well as stick in any relics you pick up along the way.

For our practice session today, we'll learn a little bit about urban sketching, a skill that is great for making art on the go during your travels and capturing the character of the buildings and landmarks you encounter. Urban sketching doesn't just need to be buildings, you can use these techniques to draw the foods you're eating, people you see and more.

Generally, urban sketching is done on location. As such, it is usually quite a quick and loose practice. So, let's look at how we can quickly draw and paint a building as if we were outside viewing it in person, when you would have the changing light to contend with. You might want to draw quickly, because you're insecure about making art in public or you're just unable to find a comfortable position in which you can sit and draw for a long time.

TIP! *Don't get caught in the trap of thinking you need a detailed sketch to begin with. We've had a lot of practice now in simplifying shapes and breaking them down into their most basic forms (pages 23 and 33), so let's bring that mindset forward with our urban sketching drawings. For example, if the focus of your drawing is a particular building, then the people around it could just be small rectangles with a circle on top for the head.*

EXERCISE
Urban Sketching Techniques with This Drawing of a Building

Supplies
- Light or Colored Pencil
- Eraser
- 0.1–0.5-mm Waterproof Fineliner Pen
- Watercolor Paints: Blue, Yellow, Payne's Grey and Red
- Watercolor Brushes No. 8 and No. 4

Quite often, urban sketchers will forego pencil sketches and start their drawings with pen, and I urge you to try to do the same as you get more familiar with this practice. However, this one involves some complicated perspective, so let's start with a really simple pencil sketch to get everything more or less in its place.

1. With the pencil, draw a line along the lower end of the paper as the horizon. Draw a short line upward around two-thirds of the way along the line and an angled line upward to form the bulk of the building. Draw a rectangle for the background buildings, with some rough lines above the rectangle for the roofs going into the distance. And, draw the rough shape of a tree in the right corner.

> **TIP!** *For help with perspective, hold your pencil up against the picture or reference you're drawing and close one eye. This will help you figure out the exact angle of things, and you can also use this technique to compare the length of one line next to another.*

1

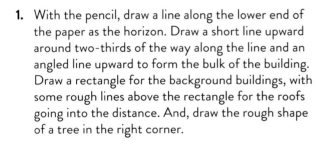

2

3

4

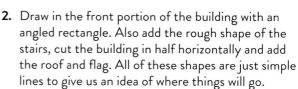

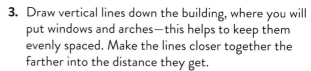

2. Draw in the front portion of the building with an angled rectangle. Also add the rough shape of the stairs, cut the building in half horizontally and add the roof and flag. All of these shapes are just simple lines to give us an idea of where things will go.

3. Draw vertical lines down the building, where you will put windows and arches—this helps to keep them evenly spaced. Make the lines closer together the farther into the distance they get.

4. If you've been as heavy-handed with your pencil sketch as I have, you might want to lightly erase the darkest of your guidelines, leaving just a hint of them to be able to work from. Now, it's time to start inking with the Fineliner. Start with the horizon and then the things that are the farthest forward—the stairs and the protruding lip of bricks between each story. The lines don't have to be entirely clean and straight; you might need to go over the same line multiple times until you have the straightest line. Of course, you can aim to be as neat as you like, but I like to think that wobbly lines add character to the drawing.

5

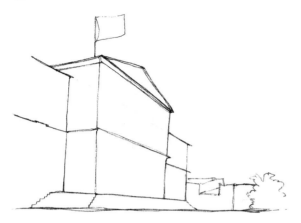

6

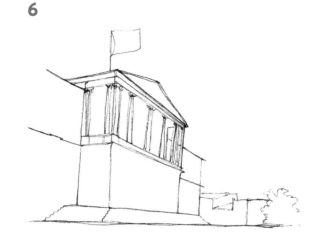

5. Continue to ink the outline of the building, adding things like the flag, tree and the buildings in the background. I chose to keep things simple by keeping the outer part of the building as a box rather than trying to curve the edges where the pillars are. Be selective with the details you include.

6. Add some lines around the roof and to border where the pillars will go. Draw the pillars in as simple tapered rectangles, remembering to follow the guidelines to distance them evenly. A squiggly line at the top of the pillars is fine to connect them with the roof.

7

7. The statues at the entrance are quite complicated, so simplify their shapes into these B-shaped blobs. These line up with the same guidelines used to place the pillars. Also, add more light lines to show the areas where the building has ornamental features sticking out.

8

9

10

8. Draw the arches along those guidelines and one up on the second level, too. Fill in the stairs with lots of horizontal lines. They don't have to be neat at all. Just resist the urge to press too hard with your pen.

9. Add the final details, like the windows and the pattern on the roof. You just need to draw rectangles and squares within the spaces you sketched out earlier. Lightly draw some lines on the inside of the upper floor as well. The distant windows are just slivers of rectangles.

10. For the smallest details, add light cobbles on the ground that are smaller as they get farther into the distance. Some simple lines are enough to create windows on the background buildings, and a few lines at different angles—mainly horizontal—make the roofs in the distances. Also add the bricks and details around the windows, as much or as little as you like, and the railings on the upper floor. You can add the people there, too. As I mentioned before, you don't need much detail at all with people in urban sketching. These are just scribbles with a circle on top for the head.

11

12

13

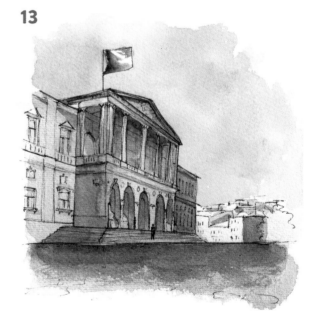

TIP! *Notice that you don't need to draw every single detail on the ground to give the impression of a cobbled street. Sometimes just drawing a few bricks or cobbles or leaves is enough to give the viewer a good enough impression of the texture you're getting across. Bear that in mind for future drawings.*

11. With the No. 8 brush, paint around the buildings and fill the whole sky with Blue. Paint everything else with a Light Cream color made from the Yellow paint or a mix of Yellow and Red. Don't worry if the colors run or if the Cream you've mixed isn't completely even, as this first layer will be covered up.

12. While the first layer is still wet, with the No. 4 brush, use cool Grey to paint in any area you see shadow. This is pretty much everywhere, except the background buildings and a small portion at the top of the main building.

13. With the previous layers almost dry, add another, darker layer of shadow in the archways, the distant part of the building, behind the pillars and under the roof. Also, shade the ground, the flag and any areas underneath things, like ledges and windows.

14. Paint in the darkest areas, such as the window frames, inside the arches and behind the pillars. Use Green to loosely paint the tree, adding some Dark Blue or Grey toward the bottom of it while the paint is still wet. Paint the rooves Orange and the flag Green and Red.

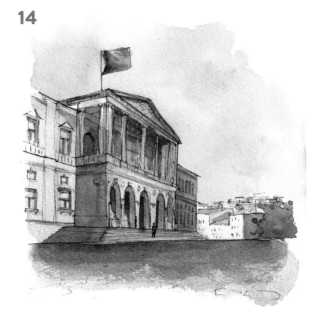

14

PROMPT
Use the Journaling Skills You've Learned So Far to Document a Day from Your Favorite Holiday

You've tackled the basics of urban sketching! Now, find old photos of trips you've taken or look online at somewhere you'd like to go. Draw a building like the one from the exercise, trying to act quickly and loosely, imagining you're on location while you work on it and don't have time to agonize over details and straight lines. Along with this, use the journaling skills you worked on at the beginning of the book to finish the page with some notes about the place you're drawing, some photos or scraps you'd like to stick in or another relevant painting or sketch.

IN MY SKETCHBOOK

For the rest of my page, I stuck in a couple of photos from the trip to Lisbon that the photo of this building was from. I included a photo of a tram, with a tram ticket stuck next to it, and I bordered the different elements with a scrap of patterned paper and some tape. I filled the remaining space with some writing to summarize the trip.

Day 18: Toned Paper

Earlier, in the Black Paper exercise on page 55, we learned the unique advantages and opportunities that come with working on a surface that isn't white. With black paper on the extreme opposite end of the scale to white, today we'll settle somewhere in the middle with toned paper.

Toned paper is generally a grey, tan or blue color, but you can really use paper of any color to reap the benefits of a more grounded background for your art. What makes toned paper so unique in its ability to enhance your work is that, as you begin with a middle value already established, you are given the flexibility to explore both the lightest and darkest parts of your drawing or painting in tandem. The freedom to create light on a blank page adds a new dimension to your work.

We'll delve deeper into this—and level up our colored pencil skills—with today's practice exercise.

EXERCISE
Detailed Colored Pencil Blending and Drawing a Nose

Supplies
- Toned Paper
- Colored Pencils: Red, Dark Brown, Light Brown, Light Blue and White. I used Pompeian Red, Burnt Ochre, Nougat, Light Cobalt Turquoise and White
- Eraser

In this exercise, notice how working on toned paper instantly softens your work without the harsh contrast of your colors against white. Pay attention to the work the paper does to contribute to the sketch overall, not just as a background, but as a feature in itself.

1. Tape the toned paper into a sketchbook. Begin by sketching an upside-down kite shape with the Red pencil.

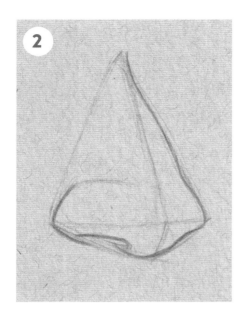

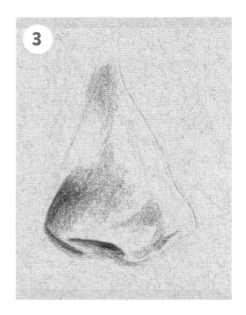

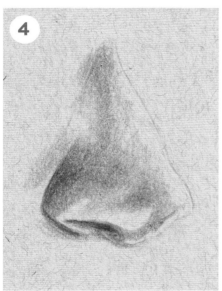

2. In the lower portion of the kite, draw the opening of the nostril and the underside of the nose. Draw the rest of the nostril in the left-hand portion of the kite, and draw the slightly curved bridge of the nose along the outer right edge.

3. Lightly erase your pencil lines until you can barely see them. Now, with the Dark Brown pencil, shade the darkest inner part of the nostril. As we've done so far with all of our shading, start with a light touch and build up layers of color. Color the rest of the shaded areas of the nostril, lightening the section of shading as you go up the bridge of the nose. Finish this shadow with some more Brown pencil near the tip of the nose.

4. Use your Light Brown now, and color over all of the areas of dark brown, spreading the color to connect the sections of shadow to each other and fill in more of the surface of the nose. Leave the area just above the opening of the nostril and the right-hand edge of the nose clear.

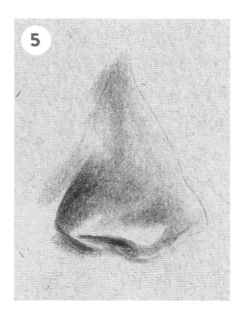

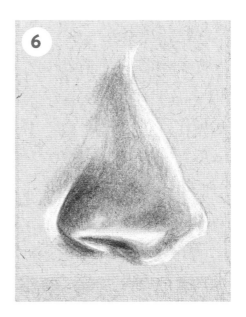

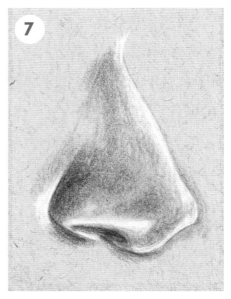

5. Along the bottom right and the bridge of the nose, lightly color a strip of Blue, blending it back and forth ever so slightly where it meets the Light Brown.

6. Use the White pencil to add the highlights along the bridge and underside of the nose, as well as around the nostril.

7. Finish with the Light Brown for the last bits of shadow around the nose, and use Red to add some color to the bridge of the nose.

PROMPT
Discover the New Challenges and Benefits of Toned Paper with a Colored Pencil Drawing

On toned paper, we are able to build gradual layers of colored pencil as the color of the paper shines through and does a lot of the work for us. By now, you should be getting accustomed to the gentle touch required for soft and smooth shading, so challenge yourself with another toned paper sketch that makes the most of a mid-tone background, and subtle layers of color and light built on top.

Skin tones look lovely sketched on toned paper, so try drawing a hand, face, foot or eye. The shine and markings of animal fur can also be achieved effectively on toned paper, even with only Black and White, so you might want to draw a tiger, penguin, a giraffe or even your pet.

Use colored pencils or Black and White to finish a page of toned paper. You might find that you enjoy it so much that you will never work on white paper again!

IN MY SKETCHBOOK

You'll remember this page from the Blank Page exercise at the start of this project (page 10). I stuck this feather, paint samples and scraps of paper onto the page. The section of toned paper here made a great ready-made backdrop for a sketch of Thierry, my cat.

I used the same colors as before, with the addition of May Green and, as with the nose drawing, I started with the darkest points, like his stripes and the areas around his ears and eyes. I filled in most of the rest of his face with the Light Brown, and added a few Pink details for his ears and nose. I colored his eyes next and finished with the White to bring out the texture of his fur, his whiskers and the little shine in his eye.

One area where I struggled was with the shading on his neck under his chin. The fur is White here, and I added Payne's Grey for the shadow; it came out looking too cool and quite out of place with the rest

of the drawing. In an attempt to save it, I layered more White over the top, using too much pressure with the pencil and leaving a waxy layer that I was unable to color over any more. While it was frustrating in the moment, I know that in the scheme of things, it is barely noticeable. I still think he looks adorable!

Paintings of the sea and sky can be incredibly evocative. A clear blue sky or still body of water can create a sense of calm and stillness, both as you paint and for anyone who sees it afterward. Similarly, a tempestuous sea or angry clouds can create a sense of darkness and doom, or just a reminder of the power of nature.

These paintings can be very detailed and complicated with layers of depth, but they can also be achieved in a simpler form with just a few steps. The simpler form of ocean and sky paintings is an easy go-to exercise for days when you don't know what to paint. With different versions of the same few steps, there are so many things you can do to paint an endless variety of beautiful seascape scenes.

Today, we're going to practice painting gradients. With a gradient as the base of our painting, we can add clouds, stars and ocean waves to transform them into beautiful paintings of the sea and sky.

Painting this scene may look complicated at first, but remember that our main goal is to get comfortable with blending gradients. Anything that we add on top is a bonus.

EXERCISE
Practice Gouache Blending and Gradients by Painting This Ocean Scene

Supplies
- Blue Colored Pencil
- Gouache Paints: Ultramarine Blue, White and Yellow Ochre
- Flat Watercolor Brush No. 12
- Watercolor Brush No. 0

1. Draw a rectangle with a line through the middle; this will be our horizon. Mix Ultramarine Blue with White to make a Medium Sky Blue, and use the flat brush to paint a strip along the top of the rectangle halfway toward the horizon. Don't worry if it looks streaky. Gouache tends to look streaky until it dries, and trying to fix it by adding water and paint just ends up making it streakier.

2. While the paint is still wet on the page, add some White to your sky-color mix and lay down another strip below the one you already created. In sweeping sideways motions, work your way up from the lighter area, painting directly into the original sky color. Keep going back and forth over them to blend them.

You might find that you've lost the initial sky color under the lighter color, so just start from the top again with your first, darker mix of Blue and again go from side to side, gradually getting lower and blending it with the lighter color.

TIP! *When blending gouache paint, extend one color entirely over the next, layering them over each other, and blend them together either with sweeping motions or small circular motions, rather than having two separate colors and trying to mix them in the middle. One of the superpowers (and sometimes difficulties) of gouache is that it reactivates when wet, especially when it is disturbed by a brush, so you can essentially layer two different colors on each other and mix directly on your page to get the color in between the two.*

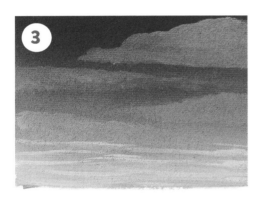

3. Adding yet more White to your sky-color mix, repeat the process from the previous two steps until you've reached the horizon line. The whole sky should still be slightly wet or tacky at this point. This is a great chance to paint in some clouds.

With a very light mix of White and a hint of Ultramarine, start painting cloud shapes into the sky (bigger toward the top of the page, flatter/closer together, toward the horizon). In the lower third of the sky, just lightly sweep the flat edge of your brush to make thin lines of clouds. As mentioned in the Tip (page 110), the paint you've already laid down will reactivate as you apply this White—this is what you want! Use small arched brushstrokes to blend the paint below with the clouds on top, helping them melt into the background.

If you struggle with the clouds, prefer a clear sky or are using watercolor paint instead of gouache, feel free to forgo the clouds or add them right at the end. We can just focus on our gradients and blending for now.

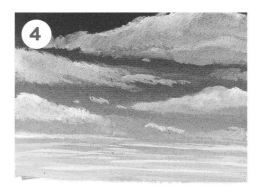

4. That's the first layer done! Gouache dries pretty quickly, so you should be able to move on to the next step quite soon. Now, we're simply repeating the same process with the clouds, but this time with pure White on our brushes. You want the paint to be quite tacky at this point, not super wet. That helps make the White really stand out and not mix in too much with the paint below. Keep painting those arc shapes along the top edges of your clouds. Then, follow up with those loose circles underneath to blend that lighter area into the background, this time with a slightly wetter brush.

HOW I PAINT CLOUDS

I'm aiming for a typical, cartoon cloud shape like this, but longer and flatter on the bottom. To achieve this, I'm using my flat brush to paint small adjoining arcs one after the other, with each a little step down from the one before. That makes the top of the cloud shape. To fill in the rest, I do the same thing with small circular motions with the flat of my brush, which also helps the cloud blend nicely with the background.

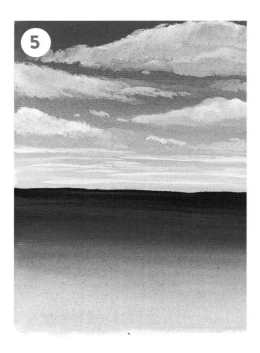

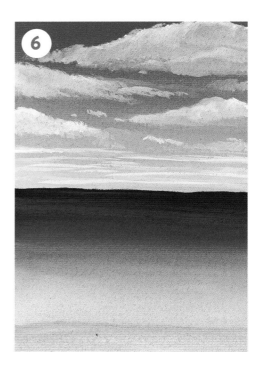

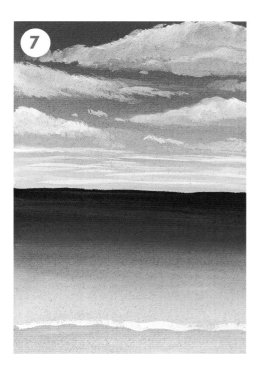

5. Painting the gradient for the sea is the same process as we used for the sky, but this time we're starting with a Blue with no White added, and then again gradually adding White as we work our way to the bottom of the page, leaving a small sliver at the bottom where we'll paint the beach. The only difference here is that I add a tiny bit of Yellow Ochre to the lightest Blue mix, right toward the bottom of the sea portion. You don't have to do this, but I think it adds a nice little suggestion of clear water, seeing the sandy ground below.

6. Mix Yellow Ochre with White and paint it along that bottom edge to make the beach. It doesn't matter if this part overlaps where the sea ends. I actually find that quite often looks better, suggesting shadow or areas of sand that have been recently soaked by a now retreating wave.

7. We're almost done already! This is my favorite part. All it takes are a few little details and suddenly things come together. With the No. 0 brush, start with a thin wobbly White line to separate where the sea ends and the sand begins.

8. All that's left to do is keep painting more White squiggly lines at random horizontally across the page, making them smaller as you head toward the horizon until they are just thin lines. Right around the horizon, you can paint tiny White dots to make the sea look like it's glittering in the sun. Finally, add some darker Yellow Ochre and some White spots to the sand to give it a little texture. And you're done!

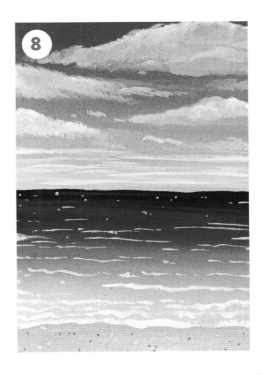

PROMPT
Work on Blending Colors with a Pair of Sky and Seascapes

Today's practice session helped us understand how a simple gradient can be brought to life with the slightest of details. We've also hopefully been able to get a better understanding of how to blend one color smoothly into another.

Change up the colors you're using and paint another pair of ocean scenes.

What about a moody, all Grey gradient? Or you could try adding more waves and clouds for a tumultuous scene. How about trying to capture a sense of clearness and serenity with a peaceful and subtle painting? Or challenge yourself to blend with bold, contrasting colors, such as Blue and Orange or Blue and Pink, and see what you end up with.

HOW I PAINT WAVES

There's a real looseness to the act of painting waves. I like to have quite a thick mix of White paint as the dry-brush effect adds a bit of texture to the frothing surf. Much like the clouds, I start with something close to the typical, cartoon style of wave. I loosen that line, smoothing out the edges, and then go even looser still. I also vary the pressure on my brush, sometimes pressing down, sometimes lightly and sometimes even lifting the brush entirely off the page and dotting it back down. These loose squiggly lines will be our waves.

IN MY SKETCHBOOK

I decided to test myself with three colors in my next gradient, and I introduced a Pink color to give the warm look of a sunset. As with the practice, my base was Ultramarine Blue. This time, I used Cadmium Yellow, which I knew would blend well with the Blue and Pink. I followed the exact same process as before, starting at the top with a Light Blue. I added a bit of Pink to the mix this time to give it a more Lilac undertone, then blended it into a lighter Yellow color, then blended again as I worked down into a Peach color, making a nice Orange in between. I decided to make the area of sky by the horizon a little bit darker, as we're looking at a hazy sky rather than the bright one that we painted earlier.

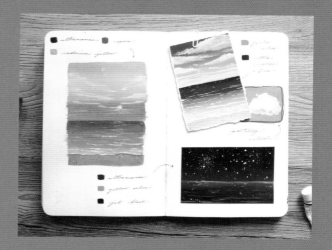

For the clouds, rather than the arced motions of my brush from before, I just swept the flat of my brush from side to side lightly for wispier clouds. Another thing to bear in mind was where I placed the highlights on the clouds. Instead of focusing the lighter areas on the top of the clouds as we did last time, I highlighted the bottom of the clouds, because the setting sun was shining up at them.

Adding the sun itself was actually an afterthought and just something I threw in in the moment. And that's the whole point of these paintings! You can add anything to your sky: clouds, sun, stars, birds, planes, spaceships and more.

The only other difference here is that I played with the color of the highlights on the waves. I wanted to show that the water was reflecting the warm light of the sun, so I painted the waves in the same way but with Peach and Pink and a little bit of White. I also added some subtle shadows.

Next, I moved on to this night scene, for which I taped off the edges with washi tape. This was so much fun, and I love the atmospheric feel it gives. Going back to

Ultramarine and Yellow Ochre, with the addition of Black, I again started at the top, blending Black into Blue and then adding a little bit of White toward the bottom. The difference here is that I decided to start the sea lighter and then make it dark, rather than the dark to light gradient we used for our other paintings. There was no reason for this, just something I wanted to try.

These paintings allow you so much freedom. They're really forgiving, so don't be afraid to just try things out, like different colors, gradients and extra elements—maybe even a silhouette of something in the foreground.

I definitely got carried away with the stars. I achieved the splatter technique with a stiff brush loaded with White gouache that I flicked toward the page. I was holding my brush too close to the paper: if you look closely toward the left-hand side, you'll see where I actually ended up smudging my painting with the brush freshly loaded with White paint. I just painted some more stars over it to give the impression of a milky way. This isn't the look I was going for, but that doesn't really matter!

For the sketchbook spread itself, I had a lot of blank space around the paintings, so I decided to make note of the colors I had used for each one.

Day 20: Recipe

When we worked on drawing the Collections exercises (page 44 and 69), we discovered how limiting ourselves to a particular category of items can actually help generate countless ideas. In a similar vein, choosing to illustrate a recipe gives you a singular focus, with lots of different elements to work on, and it comes with the greater challenge of getting creative with how you approach drawing ingredients that you ordinarily wouldn't. Illustrating a recipe can also be seen as a form of journaling, as you write and record the details.

For our intro into food illustration today, we'll master ink and watercolor paintings. These can create lovely stylized illustrations that can be used in a myriad of ways. We'll start with a croissant illustration to get the hang of this technique.

EXERCISE
Combining Ink Drawings with Watercolor with This Croissant Painting

Supplies
- Pencil (I used a red colored pencil, but any pencil will work fine)
- 0.1-mm Waterproof Fineliner Pen
- Eraser
- Watercolor Paints: Yellow, Red and Blue
- Watercolor Brush No. 4

1

2

1. Use the pencil to draw a curved crescent shape like a moon. Then, split it up with slightly curved lines at random that fan out from the center.

2. With the Fineliner, draw around one of these sections. Add some slight ridges to the lines along the outside of the croissant.

3

4

5

6

3. Add more of these sections at random, following the guidelines you drew earlier. Make the wedges wider at the top and have them all converge toward the center. Leave the center wedge as it is.

4. Use your pen lightly to add stripes along the contour of the croissant. The key is to press very lightly and have all the lines coming together toward the middle. You can also add some crumbs on and around the croissant, if you like.

5. Erase all pencil lines. Then, with light Yellow paint, and in curved stripes that follow the lines you've already drawn, paint the croissant, leaving some strips of white along the shape and a white highlight in the middle.

6. Do the same thing with a more Orange mix of paint, again leaving gaps of stripes. While the paint is still wet, darken the area closest to the middle with a darker Brown, mixed by combining Red, Yellow and a bit of Blue, and let that blend into the lines you've painted.

Can you believe that's it already?

With ink and watercolor paintings, you don't need to do much layering of paint, as the lines should do a good job of pulling everything together. Without the lines, your painting underneath should be really simple and loose. Trying to add too much detail with paint might actually make things look busy, and you could lose or confuse the details you already added with the lines.

PROMPT
Explore This Style by Illustrating Other Breakfast Items

Now that you've mastered this technique, either illustrate the ingredients that make up a croissant or fill the rest of your page with more illustrations of breakfast items. Come up with your ideal and most indulgent breakfast menu. If you're not into breakfast or croissants, choose your favorite meal and draw all the elements that go into it. You can even write out the recipe on the page next to it.

IN MY SKETCHBOOK

For my page, I added a jar of strawberry jam, some streaky bacon, a blueberry muffin, a sunny-side up egg, a steaming mug of black coffee, some fresh berries and an avocado. It was a constant exercise in mindfulness and restraint to not get too carried away and to keep the watercolor painting simple, letting the line work do much of the talking. The egg is a perfect representation of just how simple you can be with the painting portion and still get an effective illustration. It's my favorite thing on the page, and yet it's so simple.

Day 21: Collage Paintings

Here's a way to create completely unique and endlessly compelling—and sometimes amusing—paintings. By collaging together various references and painting from that fusion of photos, you can invent anything and still capture it realistically in a painting.

You don't have to physically collage the photos together either, you can simply switch from one relevant reference photo to another as you develop each section of your work. This technique is great for coming up with original faces. For example, if you wanted to create an original character with believable features, you could combine different facial features from existing people. And, for a kookier portrait, you could use facial features that don't match in size or add the features of an animal or insect. Or, you could invent your own creature or alien by combining the legs of an insect, the body of an animal and even elements like tree branches or architectural or technological objects. This technique will even work for an invented place, like a fantasy landscape with a waterfall coming out of a tree in the middle of the desert. The possibilities are endless!

Your collages can be grounded in reality or as wild as you can imagine. In our practice exercise, we'll combine a man with a penguin and a sunflower—because, why not.

Photo credit: Jill Burrow, Kelly L and sumit kapoor on Pexels; Sonyuser on Pixabay

EXERCISE
Painting and Collage Technique with This Penguin-Man

Supplies
- Colored Pencils: Blue, Dark Grey, Orange, Yellow, Light Grey, Dark Green
- Eraser
- Watercolor Brush No. 4
- Watercolor Paints: Yellow, Brown, Grey and Green

We're also going to be trying a new watercolor illustration style today. As with the style we used in our Recipe (page 115) exercise, the watercolor portion is kept simple and acts as a base color with the additional layer—in this case, colored pencils—providing the details.

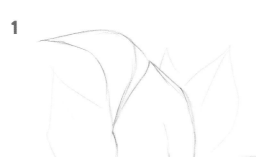

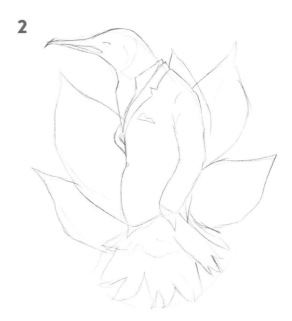

1. With your blue pencil, start with a rough sketch to get each of the elements in place. The penguin is like a crescent moon with a flat bottom end that leads into a sort of trumpet shape for the flower. Add the leaves behind, and lightly sketch where the arm and collar will go.

2. Add details to the sketch by shaping the penguin's head so that the beak is long and thin, and the head is rounded. Lightly sketch the markings on its face. Add the shape of the collar and a pocket to the jacket and some petals to the flower.

3. Lightly erase your initial pencil outlines, enough that you can only just see them. With the Yellow paint, color the underside of the penguin's beak and the area around its neck. Fill the whole flower with Yellow paint, then add Brown to create shadows in this section while the paint is still wet.

4

5

6

4. Start the Grey layer now with a flat wash of Grey over the jacket, a cooler Grey on the penguin's neck and a darker Grey on its head, leaving the eye and the top of the beak white.

> **TIP!** *You don't have to be neat or detailed here—try to keep it as simple and flat as possible—we'll add most of the details with pencil.*

5. The final step with the watercolors is to paint the leaves Green, both behind the penguin and at the start of the sunflower. Use any excess paint on your brush to darken the sunflower's inner shadow.

6. Once the paint is dry, take a Dark Grey pencil and shade the majority of the penguin's head, its markings, neck and the lower part of its chest.

7

8

7. Now use the Orange pencil to shade around the neck and beak, blending out into the yellow that is already there. Use your Orange and Yellow to color the eye and the Dark Grey pencil to finish the eye.

8. Lightly shade the outlines of the collar and blend the shading into the white of the page. Use Yellow and Dark Grey to finish the chest and shade the opening of the jacket.

9. With the Dark Grey pencil, color the creases and details on the jacket, leaving a strip of white along the back of the arm.

9

10

11

12

10. Go over the jacket with the Light Grey to blend the shaded areas in with the base watercolor layer. Use the Dark Green pencil to start the shading on the sunflower leaves.

11. Color some shaded areas on the sunflower petals, focusing most of your shading to the base of each petal.

12. Use Orange to create a gradient on the sunflower between the Dark Brown shading and the Yellow paint beneath.

13. Finish the leaves with lightly colored stripes of Green, leaving the middle of each leaf clear of pencil marks.

PROMPT
Create Something Completely Unique with a Painted Collage of Different Images

Watercolor and colored pencils work really nicely together to build color and texture. Use this technique on a colorful collaged illustration of your own. You can combine more animals with people or create a unique plant or place. You might want to try a funny portrait or a complete mishmash of random items. The choice is all yours!

13

IN MY SKETCHBOOK

To follow the bird-human hybrid theme, I drew this peacock with an oversized hand as its tail. Although I struggled a bit with the skin tone of the hand, the layers of colored pencil over the blue of the peacock's body lent itself really well to the texture of the feathers, and I think the peacock and the penguin make a dashing pair beside each other on this page.

Day 22: Commission Yourself I— Ink Illustration

Many artists will work on commissions where they are tasked with the opportunity to make art for a client, a person or business. The challenge of a commission comes in interpreting the description of the required artwork in the client's brief, but that is also where the benefits of commission work shine, as you start to think outside the box and come up with unique ideas.

You don't need to be a professional to get practice with commissions; in fact, it's a great way to set projects for yourself, test your creativity and build up your portfolio. So today, we're going to challenge ourselves to illustrate a poem and, as we go, we'll learn about sketching and shading with a pen in this classic illustration style.

The poem we're starting with is called "My Shadow," by Robert Louis Stevenson, and the particular line we'll focus on reads:

I have a little shadow that goes in and out with me,

And what can be the use of him is more than I can see.

EXERCISE
Ink Drawings and Illustrate a Poem with Me

Supplies
- Pencil (I used a red colored pencil, but any pencil will work fine)
- 0.1-mm Fineliner Pen
- Eraser

The main challenge of any commission is coming up with an idea of how to translate the brief into a piece of art. This is the time to write down or sketch any and all ideas that come to mind. The idea that came to me first was the thought of someone going in and out through a door and their shadow following.

I drew a small thumbnail first to test the composition and found that it looked quite creepy. After a few more thumbnail sketches of different ideas, I kept gravitating back to the initial idea so I decided to embrace the creepiness, which seemed to fit with a reread of the poem with more of a spooky tone. If you'd prefer, you can also practice this with something funny and unexpected—such as a dinosaur or someone standing in a funny position—silhouetted in the doorway.

1. With the pencil, draw a wide rectangle with a horizontal line across the upper half. Draw a smaller rectangle to form the doorway in the upper half, a line going straight down from the left-hand edge of the doorway to the bottom of the page and another from the right-hand base of the door frame diagonally outward to the right-hand side of the page.

2. In the middle of the door gap, draw a small square that is rounded at the top, and a small circle on top for the torso and head. From the head, draw two lines outward at diagonals to the floor to place the legs. Mirror these steps for the shadow, stretching it out in the direction of the floor wedge.

3. To neaten up the silhouette and his shadow, split the upper square into a torso with two arms and join the legs to the body. Do the same for the shadow.

4

4. Now, outline the edge, floor and doorway with pen, leaving the floor within the doorway clear. Color in the innermost parts of the silhouette as dark as you can, and do the same for the bottom of the legs. Read the box for shading tips before you move on to the next step.

PRACTICE SHADING

Here are some ways to practice your shading with a pen.

Draw out some boxes and try to color one as lightly as you can with the least pressure on your pen. Now try to color one as dark as you can. In between, try to get a medium shade with medium pressure. As with the ballpoint (page 44) drawings, start with light pressure and gradually build up.

Another way to shade with a pen is to keep the pressure on your pen the same, but space apart the lines you're using for shading. Try this for three more boxes: dark, medium and light.

Finally, you could try hatching. You can use this with either of the previous techniques. Essentially, to build up layers and darken the area, go over it with another round of lines in a different direction and repeat this as many times in as many directions as you like until it's as dark as you want.

As with ballpoint shading, use little pressure and aim for even strokes in one direction rather than zigzagging your pen across the page.

With what you've learned about shading, draw another couple of boxes and try to color them with a gradient from as light to as dark as you can get and vice versa. Do this a few times to get used to the amount of pressure needed, how far apart your lines need to be or how much hatching you need, depending on which technique you prefer.

Now that we've practiced, let's move on to step 5.

5. Color the rest of the body and shadow it in a medium shade. Concentrate more shading lines where the dark area of the legs fades into the rest of the body.

6. Now, shade along the floor from the edge of the page toward the strip of light at the door. Start dark at the edge of the page and get lighter—to the lightest you can manage—before stopping at the strip of light.

7. Keep shading like this in strips along the floor. There might be a bit of a mark where you join one area with the next, but, once you're finished, it shouldn't be too visible. Just try to use light strokes, aiming for layering more lines rather than going straight in with dark ink.

8. When you have finished the floor, do the same thing around the door with much smaller sections going outward from the door where it is lightest into the rest of the room getting darker.

9. Now, start with your darkest shade at the very edges of the page, color in toward that lighter area toward the door. Once you get to the lighter area, you might need to layer over it a bit to better blend the dark with the light. Wait for all the ink to dry, then carefully erase your pencil marks.

PROMPT
Illustrate a Poem, Book Page or Magazine Article to Generate New Ideas

Now, find a poem you love and use thumbnails (page 75) to brainstorm some ways to illustrate it. Narrow your focus to a single line or verse and look out for the key words, imagery or themes you come across. When you're happy with your idea, use the inking techniques we've learned to illustrate the poem.

If you don't want to illustrate a poem, you can also illustrate a magazine or newspaper article or a passage from a book you love.

The woods are lovely, dark and deep.
But I have promises to keep,
And miles to go before I sleep,
And miles to go before I sleep.

robert frost

IN MY SKETCHBOOK

For my next poem, I chose Robert Frost's "Stopping by Woods on a Snowy Evening," in which snowy woods are described as "lovely, dark and deep." To make the most of the different hatching techniques learned and the different values practiced, I used the depth of the drawing to my advantage and had the background trees getting lighter and lighter. I also faded the path and used negative space to show the snowy ground.

In the Timed Challenge (page 23), we discovered how creative challenges can help us loosen up. Now we'll look at the ways a challenge can promote getting creative with ideas and thinking outside the box.

The goal of this color challenge is to think of as many things as you can that are one particular color and paint them all. You will have to think deeply and rack your brain for ideas; in the process, you'll come up with things you ordinarily would never have thought to paint. Another benefit of this challenge is what you will learn about color along the way, creating different mixes of one color and seeing which other colors complement it to suit all the different subjects you think of.

EXERCISE
Detailed Watercolor Painting by Painting a Blue Jay

Supplies
- Blue Pencil
- Watercolor Paints: Phthalo Blue or Blue, Quinacridone Orange or Orange and Yellow
- Watercolor Brush No. 0
- Watercolor Brush No. 4, optional

I promised we'd look at painting birds in more detail after the Timed Challenge (page 23), and it's finally time to do so with this painting of a blue jay.

1

2

1. With the pencil, lightly sketch the rough bird shape: make it almost triangular with a strong curve on the underside. Add guidelines for the eye, beak, leg and tail.

2. Use the guidelines to draw in the details of the bird. Square off the head and define the neck. Add a wing through the middle of the body, and add a small triangle where the leg meets the body.

MIXING GREY WITH BLUE AND ORANGE

You can vary the temperature of Grey with different amounts of Blue and Orange. Under the neck and tail, I've gone for a cooler Grey.

EXPERIMENTING WITH SHADING

To fade an area of shading like this with the rest of the painting and add the texture of feathers, paint the shape of the area you'll be shading, leaving space to blend it out. Then use small brushstrokes along the edge of that shape all going in one direction to start to blend it out into the rest of the painting. Clean off your brush and continue to blend out that edge with more brushstrokes, all going in the same direction outward from the shaded area.

You might want to experiment with your brushstrokes, see how thick and thin you can get them going up and down with your brush to warm up the motion in your hand and wrist.

3

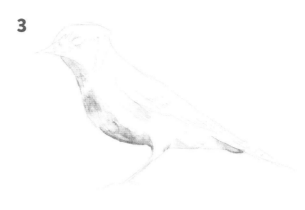

4

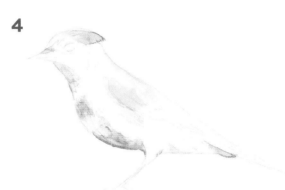

3. Mix a Light Grey with your watercolors; if you're using Phthalo Blue and Quinacridone Orange, it's an even mix of them both. Use the No. 0 brush to shade the belly, under the tail, wing, beak and eye with lots of small brushstrokes. Check the box to the left for tips about mixing Grey with Blue and Orange and shading.

4. With your lightest Blue, paint the top of the head and beak and the first portion of the wing. Continue to use small brushstrokes as you fill in each section, and clean and dry your brush to pick up paint, and lighten areas like the forehead and middle of the wing.

5

6

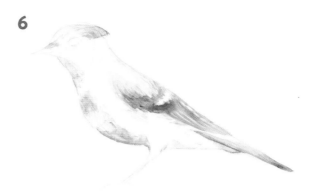

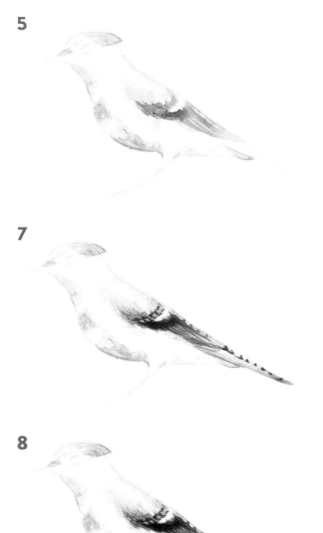

7

8

5. Mix a darker Blue. Continue to paint down the next section of the wing. Remember to leave the White streak and lengthen your brushstrokes where the feathers are longer.

6. Paint the bottom of the tail now, making it darker toward the tip. Also, use this opportunity if the previous sections of the wing are already starting to dry to go back with a few more light brushstrokes to blend each part of the wing with the other and add the slight detail of more feathers.

7. Mix your two colors again, this time for a darker Grey or Dark Blue. With short brushstrokes all following the direction of the wing, paint in the stripes, concentrating the darkest area just below the White streak. Use a very light Blue to layer over the neck slightly.

8. With that same dark color, paint the underside of the tail and use a wet brush to blend that shaded area into the body. Paint the legs with this color and leave a gap where we'll paint the highlight that separates one leg from another.

9. Use that darker color again to paint the underside of the beak, and the eye and facial pattern. You should still be using small brushstrokes that go in the same direction and follow the contours of the bird's face. Leave a small highlight in the eye of the bird or add this later with some White paint or a gel pen. Paint the gap between the legs with a light grey and use grey to blend some of the face markings with the rest of the bird, using the same technique as the belly shading in the beginning and blending out the edge with lighter brushstrokes.

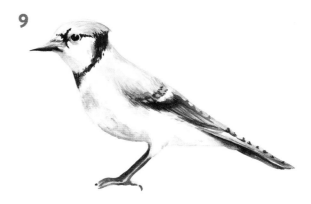

10. You can also choose to paint in a rough background with the No. 4 brush; just be careful not to let it swallow the legs if you're painting a dark background. Carefully paint around the bird, leaving a small white border around the belly and beak to suggest backlight. Here I just added some Yellow to the paint I had already mixed with Blue and Orange and blotched them on the paper at random, letting each new color blend with the next.

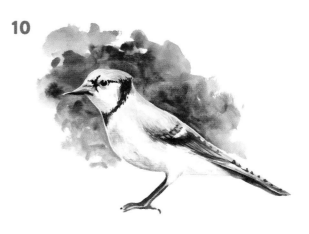

PROMPT
Engage in Some Out-of-the-Box Thinking by Painting as Many Blue Things as You Can Think Of

Now that we've worked on our watercolor painting technique—discovering how we can use brushstrokes for texture and how we can layer to build depth—let's see what else we can think of that is blue, and let's fill the rest of our page with drawings of blue items, while getting in some more watercolor practice.

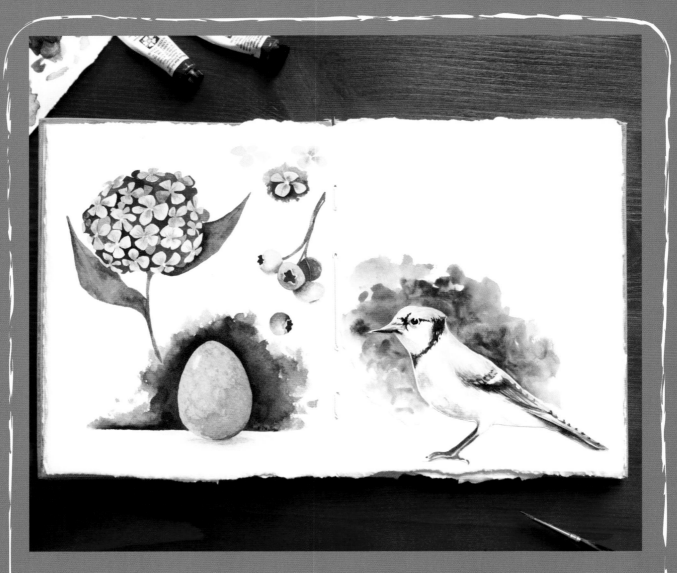

IN MY SKETCHBOOK

Thinking of blue things is surprisingly difficult!
I chose a duck egg, some hydrangea and blueberries.
You can see the layering process I used for the
hydrangea; I also completed the egg and blueberries
in several layers. Also, with the egg I experimented
with water in the paint while it was still wet to
achieve an interesting surface texture.

The egg looked funny just floating there, so I added
a background and I left room on the page for when I
think of more blue things. For now, my list includes:
a blue whale, bluebells or some trendy blue-lensed
sunglasses.

Another version of this challenge would be to think
of loads of things that are a certain shape, such as
filling a page with round things.

CHALLENGE YOURSELF

Get out of your comfort zone, try something new and push yourself with your most ambitious work

We've come such a long way already! By now, you should have lots of full sketchbook pages brimming with creative experiments, new skills and ideas. For this next portion of the project, we're going to exceed our own expectations of what we're capable of by working on our most daring and gratifying exercises so far.

We'll challenge ourselves with detail (page 145), color and style (page 141), culminating in our boldest project to date, as we attempt to combine many of the lessons we've learned along the way in our most realistic painting (page 165).

And, though the difficulty level is stepping up, the fun doesn't stop. Stay curious and courageous, solve problems as you go and get excited to see just how much you can accomplish.

Day 24: Plein Air

Painting plein air refers to the act of painting outdoors. Away from your desk and outside the walls of your studio, you're able to observe and capture the very real landscape before you, with all its depth, movement and detail.

These paintings tend to be loose and quick—or at least begin that way and have details added later—because, unlike a photo reference, the scene before you transforms constantly with the changing light of the day. With only the limited tools you brought with you at your disposal, a plein air painting encourages you to be imaginative with your paint choices and selective with your limited time. And, after a few sessions of painting *en plein air* you'll find that you've been able to streamline your landscape painting process to make the most impact in your work with the least overthinking.

You can have anything you can carry in your plein air painting kit. For many, a small canvas and a handful of paints, carefully selected for their versatility in mixing, is more than enough. Sketchbooks can make the perfect portable canvas for art on the go.

To get comfortable with painting out in the open, you might find it helps to warm-up with a landscape painting process that works for you first. For today's practice exercise, we'll learn a method of building up a simple landscape painting in steps that can be replicated for future paintings outdoors.

EXERCISE
Landscape Painting with This English Countryside Scene

Supplies
- Pencil or Washi Tape or Masking Tape
- Eraser
- Gouache Paints: Blue, White, Yellow, Red and Yellow Ochre
- Medium Flat Paintbrush: I used a Flat No. 5

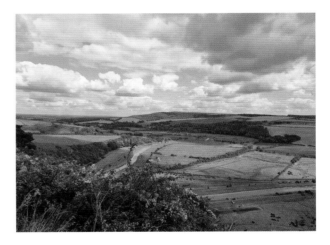

We'll work from a photo taken on a sunny day trip to the East Sussex countryside. Pay attention to the progression of each step, as we'll aim to use a similar process when we go outside to paint again *en plein air*.

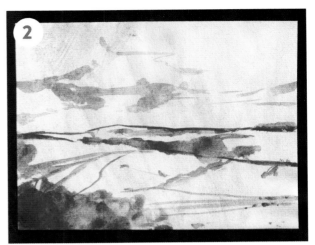

1. Draw or tape a rectangular border on your page and use a light wash of Blue to fill it.

2. Use light, loose brushstrokes with a slightly darker wash of Blue paint to block in the key areas of the scene, like the horizon, any areas of shadow and the lines that mark different fields and waterways. This just needs to be a loose sketch to get the key components of the composition in the right place.

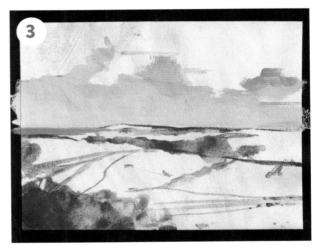

3. Mix your Blue with White and a little bit of Yellow, and start to paint the sky up to the large body of clouds. Add more White to the mix as you get closer to the horizon, and use a blueish Grey there to paint the strip of distant land.

TIP! *You should be working in quick, loose and decisive brushstrokes, and constantly referring back to your reference.*

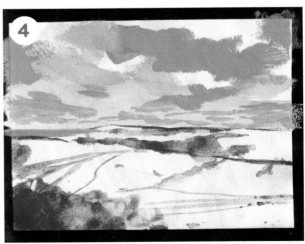

4. Mix your Blue, White and Red and a bit of Yellow Ochre to make a Grey color, and paint in the bottom of the clouds.

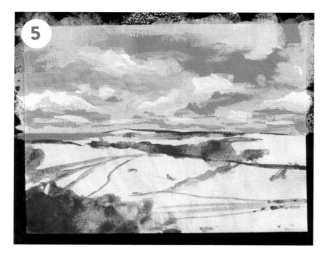

5. Use White to paint the cloud highlights. You're working quickly, so all your layers of paint should still be quite wet as you work, allowing the White to blend with the Grey with each quick stroke of your brush. Layer on as much White as necessary, until your clouds are shining in the sky.

6. Use a dark purplish mix of paint to start blocking in the darkest areas of the painting: the shadows of the trees, the borders of some of the hedges and the foliage in the foreground.

7. Mix an earthy Medium Green, using the Blue and Yellow Ochre and a hint of Yellow. Paint in the darker areas of the fields that aren't in direct sunlight. With a browner color mixed with Yellow Ochre, Red and White, paint along the edges of the stream.

8. Fill the rest of the fields and the streams with a lighter Green and Cream color. Work in large, simple blocks of color for now; you can blend and add detail soon.

9. Mix your Blue with Red and a little bit of Yellow for a Dark Brown to add small details like the hedges and the shadowy areas of distant land. Add some texture to the land closest to us. And use a Light Blue-Grey to paint the water into the streams, using a strip of White to make them shine.

10. Mix your Blue with Yellow and a hint of Red for a Dark Green. Use it to layer the trees in the distance and foreground.

11. Add a final layer of lighter Green in small dots and blobs to the trees in the foreground, adding small twigs and branches here, too.

12. Erase the pencil lines or peel the tape to reveal a clean border.

PROMPT
Release the Fear of Creating in Public and Paint Outdoors

It's amazing how a handful of colors and some strategic layering can build a landscape from nothing. The key is to keep looking at your reference as a whole, seeing large areas of color and light, and blocking in several of them at a time.

If you're feeling up to it, try to do this by painting outside!

Along with your paints and sketchbook, take a jar of water to clean your brush in, some rags or paper towel to wipe your wet brush on, some kind of board that you can rest your work on or clip your entire sketchbook to and a lightweight palette to mix your paint on. Find a comfortable spot on a bench in your local park, or sit in your back garden or balcony or at a bus stop. Bring a blanket if it's cold or something to shade you from the sun if it's sunny. Bring some snacks and a friend. Make it a fun excursion and don't take the painting session too seriously.

If you can't find a good painting spot outdoors, choose a photo to work from, but commit to keeping your landscape painting as loose as you can.

IN MY SKETCHBOOK

I couldn't find a good spot to sit and paint on this wintry morning at my local park, so I actually completed this painting standing, with my sketchbook simply held in my non-painting hand. I think you can see from the painting that it was chilly out, so I cheated and skipped the underpainting, which I actually went on to regret, because a quick layer of Yellow Ochre under everything would have saved me a lot of time spent building up the ground in the foreground. After trying to work too quickly on the path and the grass, my page was soaked with paint, and I was unable to layer on any more paint without it all blending. So, I spent 15 minutes finishing the foreground at home!

The rest of the painting also only took about 15 minutes. I'm a very private artist and feel insecure when people see my work in progress, which worked in my favor to keep my mark-making quick and loose, as I rushed to get this painting done before encountering any dog-walkers or passersby. Over time, it would be great to keep building up the confidence to commit to more time and more detailed paintings outdoors. Regardless of how accurate your painting is, you have to admit there's something uniquely exhilarating about painting in the open.

Day 25: Color Palettes II— Limited Palettes

In our exploration of color so far, we've looked at different types of harmonized color palettes (page 28) and we've worked in monochrome (page 91). Today, we'll look at the art of mixing colors, and the combinations and possibilities available with just two or three colors at our disposal.

It is tempting to think we need every color of paint or pencils to accurately depict the art we want to make, but mixing the right limited palette of colors can be just as effective as using 100 individual colors.

Limited palettes also work to give your art a particular style, depending on how your chosen colors alter the temperature of your painting, how light or dark you can make it or whether the colors you mix result in something contrasting and colorful or something more muted.

The Zorn palette is a famous example of an effective use of limited colors. With an impeccable understanding of value and the use of just Yellow Ochre, Ivory,

Black, Vermilion or Cadmium Red Light and Titanium White, Anders Zorn was able to create a beautiful variety of paintings.

Generally, even with just one warm and one cool color —and the addition of White if you're working in an opaque medium—you can get started with an effective mixture of colors for any painting project.

We'll test this by painting a watercolor portrait with just Blue and Red!

EXERCISE
Color Mixing by Painting a Portrait with a Limited Palette of Blue and Red

Supplies
- Watercolor Paints: Blue and Red. I used Phthalo Blue and Perylene Scarlet
- Watercolor Brushes No. 4 and No. 0
- Pencil (I used a red colored pencil, but any pencil will work fine)
- Eraser

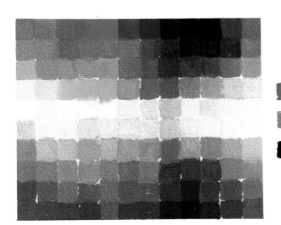

1

2

3

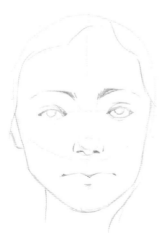

Start by just swatching a few different combinations of these colors together, using the No. 4 brush. Adjust how light or dark they are, and how much they skew in the direction of one color or the other. With the same two colors, you can make different versions of Light Pinks, Medium Greys, Dark Purples, Cool Blues and several colors in between.

1. Use the pencil to draw a head shape. Sketch a circle with a line vertically through the middle and horizontally just below the halfway mark. Add another section below for the jaw.

2. Lighten those initial lines with the eraser, and draw a narrow triangle in the center of the face for the nose. Trace upward from the outer edges of the nose and start an eye here on each side, with two eyebrows above them. Draw the ears from the same line as the eyes down to the bottom of the nose, and add a thin line for the mouth in the gap between the initial circle and the bottom of the chin.

3. Add details: some hair to frame around the edges of the face, eyelids and irises for the eyes and nostrils on the nose. Erase the rest of the guidelines.

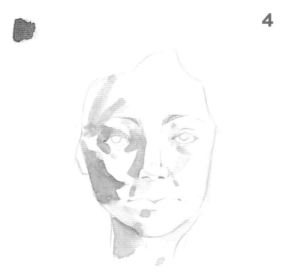

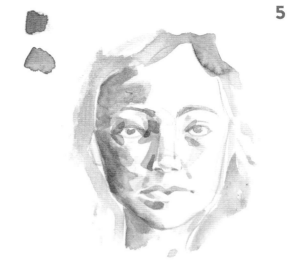

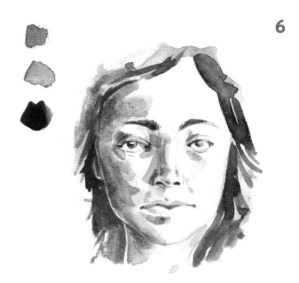

4. We'll start with the Red alone, mixed with water into a Light Pink. Paint the left-hand side of the forehead in decisive, blocky strokes. Paint around each corner of the left eye and over the top of that eyelid. Leave some white space at the cheekbone, and paint down the left of the face to the chin and under the bottom lip. Paint the neck in two large brushstrokes on either side, and paint the area to the left of the nose and upper lip in another couple of brushstrokes. Finish with a jagged line that goes from the inner right eyelid, under the eye and down the cheek toward the nose. Add a laugh line and a small shadow to the right edge of the face.

5. Mix a Light Grey with the paint now, and use it to start filling in the hair, in chunky strokes of paint around the face. Use the same color to deepen the shadow along the left side of the face and neck, paint the eyebrows and irises, and add shadow to the lips and chin. Use smaller, lighter strokes to paint the bridge of the nose and the inner corners of each eyelid.

6. Mix a darker Purple-Grey now and finish, using the No. 0 brush, with some more defining marks in the hair and eyebrows. Darken the irises, leaving a sliver of highlight in the eyes. Add shadow to the nostrils, the corners of the mouth and the ear. Although these are not traditional portrait colors, this still reads as a face, thanks to the clever use of values and tone variations.

PROMPT
Get Used to Color Mixing by Testing More Limited Palette Combinations

Sketch some more faces like this, adjusting the size, shape and placement of the features. When you have finished all your sketches, choose a couple of two-color combinations you'd like to try mixing. Paint each face one by one in a similar fashion to the practice round, to experiment with which color combos work well.

IN MY SKETCHBOOK

For my first portrait (top right), I used Sap Green and Orange. This resulted in a muddy mix and left the subject of this portrait looking unwell. I don't think I'll use that blend of colors again!

Next (top left), I mixed Orange with Prussian Blue, for a much more harmonized scheme. I was able to achieve rich Browns and deep Greys, too!

I used Prussian Blue again for the bottom right portrait with Magenta (and a hint of Yellow). This one is my favorite by far, and the combination of colors is one I'll note for future paintings.

The last of the main portraits (bottom left) was mainly made up of Red; I added a little bit of Light Blue to some of the shadows after painting in the background.

You could spend all day sketching random faces and using different combinations of two colors to shade them. How many color combos can you come up with?

Day 26: Playing with Scale I— Miniature

We've been pushing the boundaries of our drawing ideas, and the tools and techniques we use to execute them. Another great way to use your sketchbook is through explorations of the different ways you can adapt existing ideas. For example, taking an idea and adding an extra element of challenge to it.

One way to do this is to play with scale. In today's exercise, we'll challenge ourselves to some tiny drawings and learn the important balance between detail and simplicity that comes with them. As well as focus, patience and a steady hand, these drawings demand careful thought about how we choose to draw any particular item, and how we can simplify the lines and shapes to achieve a readable finished drawing that isn't too busy with unnecessary details crammed into one small space.

These little drawings can make great doodles for your journaling pages or can be used as a way to fill a page bit by bit, with one tiny drawing a day on a single page until it is full. Despite requiring a level of concentration to work on, tiny drawings have the benefit of only taking a few minutes and can therefore be used as a way to commit to making art every day. If you don't have time for a full-scale finished painting or an entire sketchbook page, you can draw something tiny and still have accomplished dedicating a portion of your day to making art.

EXERCISE
Capturing Important Details by Painting This Tiny Snake Plant

Supplies
- Pencil (I used a blue colored pencil, but any pencil will work fine)
- 0.1–0.5-mm Waterproof Fineliner Pen
- Eraser
- Watercolor Paints: Yellow, Green and Brown
- Watercolor Brushes No. 2 and No. 0

To get an idea of the steps that will go into this drawing, and for a comparison of how you can reduce the level of detail as the scale of your drawing changes, we'll start by drawing the snake plant at a slightly larger scale.

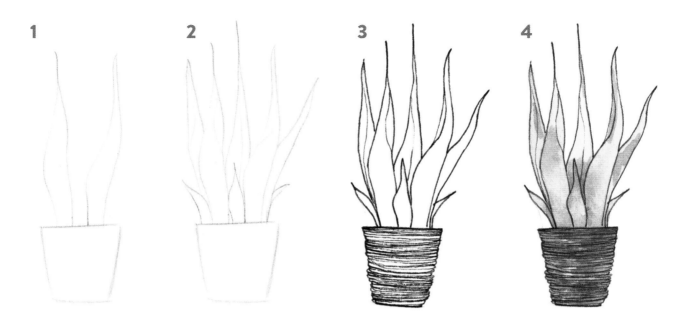

1 **2** **3** **4**

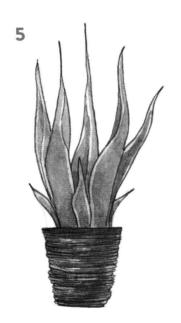

5

1. With the pencil, start by drawing a plant pot as a square that is slightly tapered at the bottom. From this, draw a couple of wavy, pointed leaves.

2. Fill in the plant with the rest of the leaves. Have some in front of others and vary the sizes.

3. Use the pen to outline everything, using a lighter touch for any smaller details. For the texture of the plant pot, start at the top and draw rows of lines one after the other. You don't need to lift your pen from the page between rows; work your way down in a sort of square zigzag.

4. Erase your pencil lines, then use the No. 2 brush to paint a wash of Yellow-Green on all the leaves. Paint the pot Brown, leaving some streaks of white along its striped texture.

5. Leaving the outer edge Yellow, use a Light Green to paint another layer on all the leaves. Add more Blue or Black to your Green toward the bottom of each leaf. And add another layer of Brown to the pot in more horizontal strips.

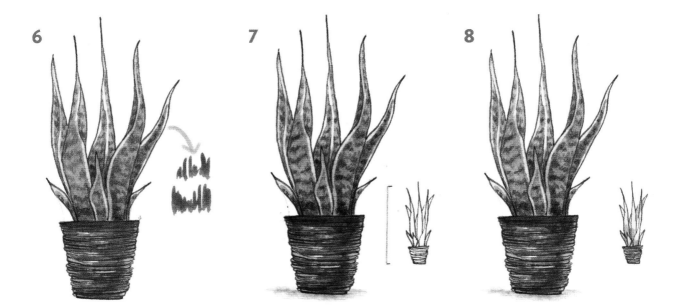

6. Use a darker Green to paint the stripes on the leaves. Leave the outer edge clear, as before. The stripes can be painted in lots of small downward marks lined up next to each other. And these marks can vary in height from one to the other.

It's time to repeat these steps but in a much smaller drawing. Pay attention to how our process differs to adapt to the change in scale. In terms of the scale, try to make it no larger than an inch (2.5 cm) in size—you could try to draw it even smaller! My drawing was around 0.8 inches (2 cm) in height. If you struggle with drawing this small for whatever reason, just aim to draw smaller than you usually would. It should be a challenge, but not so impossible that you're left disheartened or frustrated.

7. Follow the same steps to complete the smaller sketch, in pencil and then again with pen over the top. You may need to draw fewer leaves and fewer, lighter stripes down the plant pot.

8. Switch to the No. 0 brush to paint the leaves and pot; start in the middle of each shape and use the very tip of your brush to work the paint out toward the edges a little at a time. Your brush should also be relatively dry; if it is loaded with paint, you might find it more difficult to control.

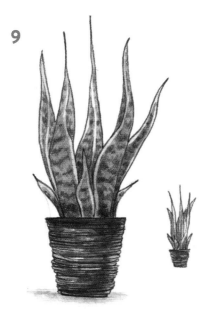

9. Add another layer of Brown to the pot, and fill in the inner parts of the leaves with darker Green paint. The key here is to pay attention to staying away from the edges and leaving that Yellow border around each leaf, so take your time.

10. Finish with the stripes on the leaves. They will be so small that you can just paint them in as dots.

The ways we adjust our approach to acclimate to the challenges of a smaller scale are lessons that we can transfer to art of all sizes. We're essentially learning one of the lessons we've been focusing on throughout much of this sketchbook project: the art of not overcomplicating our work and the impact of fewer, more considered actions.

PROMPT
Balance Detail and Simplicity with More Tiny Paintings of Household Items

Continue to fill the rest of your page with additional miniaturized household items. Explore a range of items to discover the challenges of conveying each of their unique attributes on a small scale. As with the snake plant, aim for drawings under an inch (2.5 cm) in size or just as small as you can manage, and pay attention to not trying to include too much detail. Think about how you can suggest certain textures or details with smaller and more careful marks.

IN MY SKETCHBOOK

Out of the tiny items I drew, some of the simplest turned out to be the most challenging. For example, drawing a pencil with enough detail to not just look like a tiny rectangle required a very fine point and the addition of a tiny eraser on the end, plus the smallest sliver of Yellow paint along the length of it to bring it all together.

I explored different textures with the knitted hat, the bristles of the broom and toothbrush, and the sand in the sand timer, where I used just a few dots to imply the presence of grains. Take your time to think about the different textures you can draw and how you can limit your mark-making as you do so.

Day 27: Commission Yourself II— Flat Illustration

When we worked on our last commission project (page 124), we looked at a more traditional illustration style, reminiscent of the engraved illustrations you would find in the early days of mass-printed books. Now we're going to try a more modern, flat illustration style as we design a book cover.

A flat illustration style is popular with book covers and movie posters, as it is easily recognizable and impactful at first glance. Key elements stand out and can instantly capture the essence of at least a core part of the story. These illustrations are popular with digital artists, but they can also be achieved with opaque paints and even collages, stencils or block prints.

The challenge with designing a book cover specifically is that rather than relying on a specific passage or word as you would have in the poem exercise, you're relying more on an overall theme to conjure up imagery relevant to the story. This is a similar challenge to one you would face if working on designing a poster for a film or an album cover. The brief you have to work with might be less literal, and therefore you must get imaginative with what you choose to illustrate and how.

Today, we'll design a cover for the Lewis Carroll story, "Alice's Adventures in Wonderland," that will hopefully capture some key imagery from the story.

EXERCISE
A Flat, Colorful Illustration Style and Designing a Book Cover

Supplies
- Pencil (I used a red colored pencil, but any pencil will work fine)
- Eraser
- Acrylic Gouache Paints, Acrylic Paints or Colored Pencils: Red, White, Green, Yellow, Brown, Blue, optional, and Grey
- Watercolor Brush No. 4

Something I thought of as an iconic moment of the book is the Mad Hatter's tea party. Anyone who knows the story could see a picture of a teacup and under-stand its relation to Alice's adventures, so I sketched a few thumbnails and ideas, and swatched a few colors before feeling ready to start.

1

2

1. Draw your teacup as an upside-down bell shape with a curved line for the handle and an oval below for a saucer.

2. Give the rim of the cup a wobbly edge, draw a shape for the shadow lightly along the right-hand side of the cup and down onto the table, and add other details like the edge details and the swirl of the handle.

3. Finish the sketch with some rounded rectangles with stems to form roses along the body of the cup, and add little hearts around the saucer. The hearts and roses are both motifs from the book! Draw an oval around the whole thing.

3

4

5

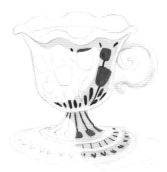

6

4. Lighten the sketch with the eraser, then use a Medium Pink to color the areas of the cup that are in shadow, leaving space for any designs you'll be painting on the teacup.

5. With Dark Red and Green, paint all the parts of the roses and hearts that are in the shadowed areas. Add some stripes to the saucer, too.

6. Mix White with the Red and Green, and finish the decorative elements on the cup and saucer that are outside of the shadow.

7. Use Yellow along the rims of the cup and plate, and add a Dark Red swirl detail to each rose that is in the light.

8. With a Medium Brown, paint some liquid into the cup. If you wish, add some Blue to Grey to make a Cool Grey, and paint the shadow of the cup on the table.

9. Finish with a Light Grey background. The contrast will make the cup instantly stand out.

9

10

Alice's Adventures in Wonderland

10. And, if you're feeling confident in your lettering, you can even add a title!

PROMPT
Think Outside the Box Illustrating an Album or Book Cover

Use this flat illustration style to design a cover for another book or an album or film that you love. Try to stick to a small handful of colors, and remember not to do any blending. What shapes can you use to simplify the design and give a clear illustration of the piece of work you're illustrating?

While the initial goal today is to explore the flat illustration style, if another idea comes to mind, feel free to lean into it. Your sketchbook should always feel like a creative space without rules, and each page like a journey that you can flow with wherever it might take you.

IN MY SKETCHBOOK

I chose to work on a cover for Herman Melville's *Moby-Dick* using two shades of Blue for the sky and sea, a Light Yellow moon to silhouette the shape of the ship and Black to create the silhouette of the whale. Silhouetted shapes like this lend themselves well to this style of illustration, as you forego detail and texture to communicate through the outlines of shapes.

I wanted to experiment with gradients, so I used a scrunched-up piece of paper as a stamp to sponge on Black paint at the bottom and blend the darkest area of the water into the Dark Blue area.

Day 28: Playing with Scale II—Close-Up

It's time for our experiments with scale to continue, this time in the opposite direction. When we shrank our drawings, we were forced to get creative with limiting the details we captured to only the most essential. Now, we're looking at zooming right in and capturing every single detail we can.

To draw the close-up details of something is a true test of observation and can even require a bit of mental abstraction. That's because the more closely we examine something, the less able we are to see it as a whole and understand each part of it in context. Imagine a close-up look at a paintbrush, for example. The closer you get, the less you are able to distinguish the shape of the brush, and, as you start to see more of the individual bristles, the more they become nothing more than a simple pattern of stripes.

We've been working hard to separate ourselves from the context of things as we draw them, suspending our assumptions about objects as a whole and breaking them down into their component parts. And, in today's exercise, we will push that skill even further.

EXERCISE
Realistic Pencil Drawings by Drawing a Water Droplet

Supplies
- Pencil No. 2B
- Eraser

As well as drawing close-up, we're going to use today's practice session to hone our pencil shading skills, building on the tips and techniques we've learned in previous chapters.

1

2

3

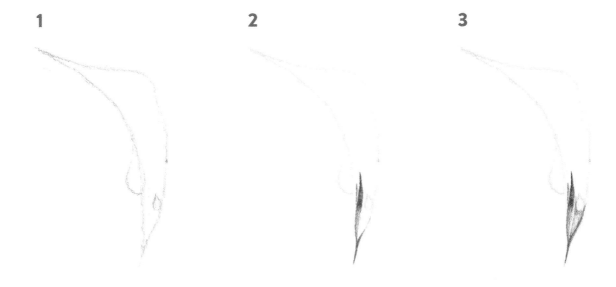

4

1. Sketch the leaf shape with a long, thin, curved triangle. Toward the bottom, draw a water droplet on the back of the leaf and a small circle where the other droplet will go.

2. Lighten your line work with the eraser before beginning the shading. Start with the dark sliver at the very tip and left-hand side of the leaf and make it darker toward each end.

3. Shade the rest of the leaf tip Medium Grey, leaving a white line running vertically between the two halves.

TIP! *Notice how we're taking this drawing one section at a time. Detailed drawings like this can feel quite daunting and overwhelming, but splitting them into smaller focus areas and putting them together bit by bit like a jigsaw puzzle is a great way to make sure you're observing each little section with attention and intention.*

4. Shade the water droplet, making it darker around the edges and leaving a small highlight at the bottom.

5 **6** **7**

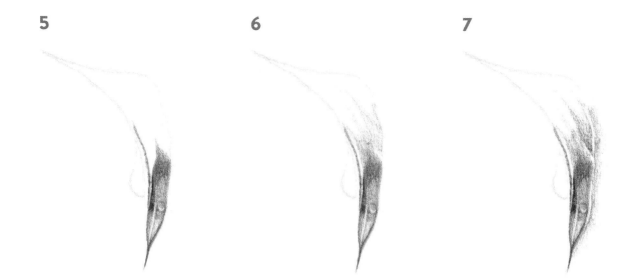

5. Continue to shade up the leaf, making this section slightly darker toward the top.

6. Now color the lighter area above the previous section. Use a very light touch to gently blend this area of shading into the areas of the paper you'll leave white.

7. Begin to lightly shade the area outside of the leaf, leaving the very edge of the leaf white.

8. For the water droplet, follow its rounded shape in stripes of Medium Grey. Don't forget to pay attention to where the droplet is completely white. If you accidentally color over these areas, you can use an eraser to carve them back out.

8

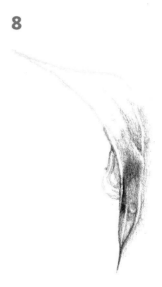

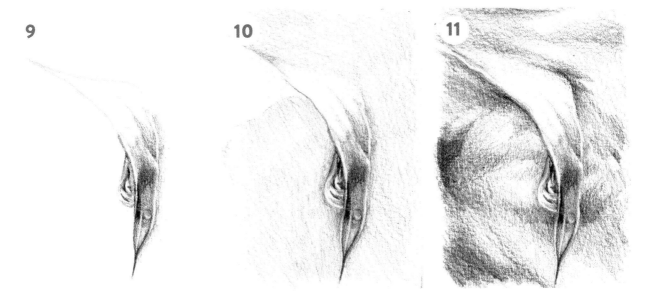

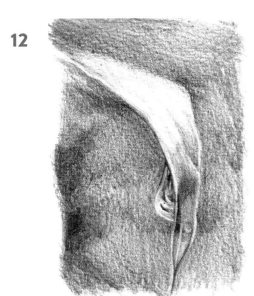

9. Shade the darkest areas of the water droplet with small curved marks that follow the contour of its shape.

10. Lightly fill in the rest of the background now, leaving a triangle white for the underside of the leaf. Begin to shade the area at the top of the leaf and blend this out into the white highlighted area.

11. Color the underside of the leaf in a consistent Light Grey, then add another layer of shading in the areas of slight variation. Begin to darken areas of the background also.

12. Deepen all of the shadows of the background to bring out the contrast against the leaf. Add depth to this background with variations in darkness from one area to another, and maintain a smooth blend of shades with no harsh edges. Do the same for the shading on the underside of the leaf.

By drawing this close-up of the leaf, we've been able to see the water droplet in a way we ordinarily wouldn't have. These stripes of White and Grey came together to create form and light.

PROMPT
Try to Sketch as Realistically as You Can with a Close-Up Drawing

With this exercise in mind, look over the space around you. Choose an object and look even closer. How does it differ from what you'd expect it to look like? Have a go at another realistic drawing of an object close-up. Look at the patterns on a leaf or the texture of a pet's fur, feathers or scales. You could also look at the weave of the clothes you're wearing, the wrinkles on a raisin or the reflections caught in the tiny facets of a safety pin. When you're on the lookout, you'll find that there are beautiful details to be found in everything around us.

IN MY SKETCHBOOK

The close up of this cat's eye has so many interesting elements to it, from the tiny reflections of its fur in the eye, the texture of its iris and the variations in tone from one area of fur to another.

I started with a very light sketch to get everything in place and then worked on the darkest areas first to help me establish value for the rest of the drawing. I focused most of my attention to the eye itself at first, taking the iris one small section at a time and paying attention to the very slight variations in tone and texture throughout. The fur, I found, was much more difficult to achieve realistically. With so many variations in value from one strand to another, I settled to just get the most important marks in with my pencil to show the general direction, length and darkness of the hairs in each area.

This sketch required some patience and a consistent light touch. The overarching challenge throughout is the ability to not only keep looking at the reference, but to look more closely than ever before.

Day 29: Alternative Self-Portrait

Artists have been using themselves as the subject of their work for centuries. With a perpetual reference to practice from or an obsessive documentation of oneself, self-portraiture has several facets and is a fascinating topic to delve into.

Because of this, a self-portrait makes a great go-to subject for a sketchbook session, as you have no need to search for a reference and your approach can be different every single time. You can opt for a very literal self-portrait and do your best to capture your own likeness, or you could choose a more figurative work of yourself that attempts to convey your character.

These portraits can be painted, drawn, photographed or sculpted, and they vary from the hyperreal to the abstract. They are a great way to get to know yourself, to see your features in a completely different way and to get comfortable with portraiture as you work from the face you know best. They can also be particularly intimidating. So, today we'll explore one method of painting that breaks down the process into manageable steps and allows us to approach even the most daunting of portraits one step at a time.

We've done a lot of work on breaking down the subjects of our drawings and paintings to their component parts to ease ourselves into capturing them, and today's practice takes that up a notch as we dissect our painting into the individual areas of color that it is made up of. This way of tiling paint in small sections makes a challenging painting much more approachable and adds an element of style to the finished piece. It can also be built on as a base layer with blending added later for a more realistic look.

EXERCISE
Using the Paint-Tiling Technique to Paint a Mouth

Supplies
- Pencil (I used a blue colored pencil, but any pencil will work fine)
- Gouache Mixing Colors: Blue or Cyan, Red or Magenta, Yellow and White
- Watercolor or Mixed Media Brush No. 4
- Eraser

Photo credit: Sora Shimazaki on Pexels

1

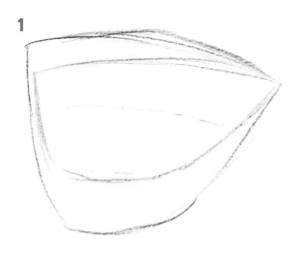

2

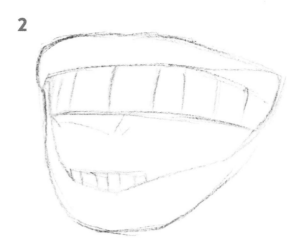

3

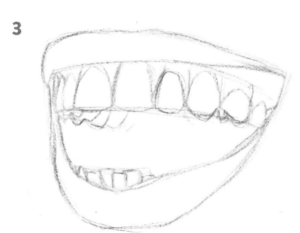

1. Lightly sketch the mouth shape as a sort of sideways teardrop with a smaller one on the inside. Draw a line through the middle where the teeth will go—notice that the line of the teeth does not follow the top lip exactly.

2. Add more detail by neatening the lines, adding more mass to the lips and drawing guidelines to space apart the teeth.

3. Now, draw the individual teeth in those spaces, paying attention to the different shapes of each tooth, as some are more rounded and others more square. Draw the back teeth as well.

4

5

6

4. It's time to start painting! Lightly erase the pencil marks, and mix a very dark Brown-Purple color, and use it in the very darkest places you can see: a majority of the inside of the mouth—avoiding the teeth—and at the very corners of the lips.

> **TIP!** *If you don't know where to start with a tiled painting—or really any painting—try painting from dark to light or vice-versa, that way, you'll always know what step is next as you work your way through the painting looking for the next color in the progression.*

5. Mix a Dark Pink and use this in the next-darkest areas—finish the inside cheek and paint the shadowy areas on the lower lip. Paint the top lip, leaving space for the highlights.

6. Use Light Pink to fill more of the lower lip and start the gums. If you discover any areas that you missed with the darker colors, feel free to go back and add them in where necessary; just resist the urge to do any blending from one color to another and work solely in one color at a time. Here you can see I added more shadow to the back area of the gums. Paint the rest of the top lip with Medium Pink.

7

8

9

7. Use a cool Light Pink to finish the lower lip and more of the gums.

8. Finish the gums with a Pinkish Purple.

9. Use a light Cream Grey to paint the teeth, leaving a lot of white, and use a darker version of this color to paint the more shadowy areas between the teeth and inside the mouth, darkening the color again for the teeth right at the back of the mouth.

10. Use White to add some highlights to the lips and gums.

10

PROMPT
Ease the Pressure of a Self-Portrait by Stylizing It in a Unique Way and Painting It One Color at a Time

Breaking down a painting into a color-by-color process like this can be incredibly helpful. But it's also a test in thinking analytically about what steps to take next. Even through the practice painting, there were some areas that we only became aware of as we went along—but the key isn't to progress along a tiled painting in a particular order, only to isolate the small parts that make the whole and take them one at a time.

Now that you have the blueprint for breaking down a complicated painting, take on the challenge of painting yourself with this technique.

You can paint your whole face or just a part, and you can choose to be as abstract or realistic as you like. Why not try distorting your features by looking at them through glass or running water? Or, take the lessons we learned yesterday and zoom right in to one particular detail. Paint yourself upside-down or pulling a funny face. Or, look at your face in harsh lighting or at an unusual angle. There are so many things you can do with a self-portrait. So, get creative and see what you can do with this painting technique in your arsenal.

IN MY SKETCHBOOK

I painted myself through the reflection of this small pocket mirror to make the scope of the challenge a bit more approachable. I also decided to squeeze my eye shut and paint the wrinkles that formed there. I thought that would give me a great chance to play with tiling out the rest of the painting, starting with the dark crease lines.

Painting the mirror itself was more of a challenge than I'd anticipated. There were lots of different areas of reflection of light around its metallic border, and I found myself layering strips of color one over the other and losing the section-by-section approach I was aiming for with this technique. The portrait itself was much more successful, as I started with Dark Brown to outline the deepest shadows and gradually worked my way through the painting with gradually lighter colors. I used much smaller brushstrokes than in the practice round, and I often varied my paint

color only very slightly between each tile, which I think gave the finished page a more painterly style.

I very rarely use myself as a reference, but this way of doing it made for a much more achievable painting session.

Day 30: Realism

Throughout this project, we've worked so hard to challenge the limits of what we felt capable of and explore new opportunities with our art. Today's final exercise asks us to take many of the skills and techniques we've learned so far and crown our many weeks' efforts with our most demanding practice exercise yet.

We have worked to capture details in previous drawings, and now we'll attempt a realistic painting, transferring the skills of observation and our understanding of color and paint-blending into an accurate depiction of our reference.

The realism movement in art refers to the depiction of subject matter as truthfully and naturalistically as possible, and one criticism of realistic art is that—while technically demanding—it forfeits the artist's opportunity to use their imagination, as their goal is to simply capture what they see without style, romanticism or exaggeration. However, the creativity in realistic art lies in the artist's process, the subjects they choose, the way they go about painting them, and, most importantly, the constant problem-solving required in any purposeful act of artistry.

Our goal today isn't necessarily to achieve a perfect, photo-realistic painting. This page of our sketchbook is dedicated to trusting ourselves and the process, to patience and acceptance of mistakes, to mindful attention and to trying our very best.

EXERCISE
Combining Everything You've Learned by Painting a Detailed Pair of Cherries

Supplies
- **Red Pencil**
- **Your Choice of Paint: Mixing Colors Blue or Cyan, Red or Magenta, Yellow, Black and White. I used Gouache**
- **Watercolor Brushes No. 0 and No. 4**

Photo credit: luctheo on Pixabay

1

2

3

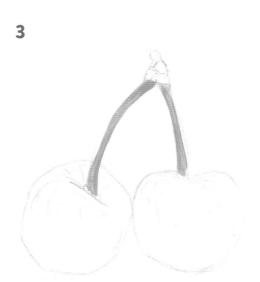

1. Sketch two round cherries—one slimmer and leaning on the other—with short stems connecting them both.

2. Add detail to the sketch by mapping out the main areas of light and shade. Break the reference up into sections, as in the process for the paint-tiling exercise (page 160).

3. With the No. 0 brush, paint the stems with Light Green, blending it into Yellow toward the top. Add subtle streaks of lighter Green down the length of the stem.

4

5

4. Use streaks of Brown from the base of the stem to add shade and texture. Concentrate an area of Brown where the stem meets the cherry. Add an area of Cream Paint where the stems join at the top.

5. Use a darker Brown to add small dots and fine lines along the stems, and to the area at the top.

6. Now, use Light Cream color to add specks of detail around the base and top of the stem.

6

7

8

9

7. Start the cherries with the mid-tone area. Use the No. 4 brush to paint these sections in Medium Pink, blending lots of small brushstrokes together in slightly varying tones for texture. Make the lower portion of the left cherry slightly darker, and do the same for the left-hand side of the cherry on the right.

8. Start the shadow now using a dark Purple-Red in some of the darkest areas of the cherries. Blend these sections wherever they meet the previous areas of paint.

9. Fill the rest of the shadow with Dark Red, close to the shade of the dark Purple-Red. Add a few lighter areas, and continue to blend each section together. Don't forget to leave space for the highlights.

10

11

12

10. Use an even darker Purple or Black to deepen the darkest areas of the cherries, such as where the two touch and around the stems. Paint the remaining surface with varying shades of Light Pink. Note that not all areas of highlight are blended with the neighboring color, so pay attention to where there is a sharp line separating them; don't be tempted to blend absolutely everything.

11. With the No. 0 brush, finish with some tiny specks or detail around the cherry with White and Red. Add strips of the most White highlight wherever you can see them, and paint in any dark or pock marks on the surface of the cherry. Use a warm Grey to start the shadow under the cherries.

12. With the No. 4 brush, blend out the shadow with the rest of the page. Now, take a breath, sit back and allow yourself a quiet moment to appreciate your efforts, not just today but throughout this project as a whole. You did it!

PROMPT
Challenge Yourself to Paint Something as Accurately as You Can

If you have any energy left, take this process and transfer it to another realistic painting. Choose an object from around your house: another piece of fruit, a sentimental trinket or the most unassuming, everyday item you can find, and give it new life in the pages of your sketchbook.

IN MY SKETCHBOOK

My very last painting of this project is of a sardine. I chose him because I can see a little bit of everything here: texture, pattern, shine, color, light and shade, all elements that will challenge my skills of observation and realism.

There are layers of paint where I tried and tried again with several approaches to painting the scales. The initial idea I had in mind to paint them didn't translate well onto paper, nor did the next attempt. In the end, I think the muddled layers of do-overs are what gives the fish its believable texture. As the scales were where I started the painting, I was able to take that lesson and use that problem-solving mindset to let the painting develop without stress or over-analysis. (Or, at least, with *much less* stress or over-analysis!)

The perfectionist in me will always want every single mark I make to be spot-on first time, but, within the comfort of the pages of my sketchbook, I'm always reminded that every step and misstep I take, as long as I am brave enough to take a step at all, will always be one in the right direction.

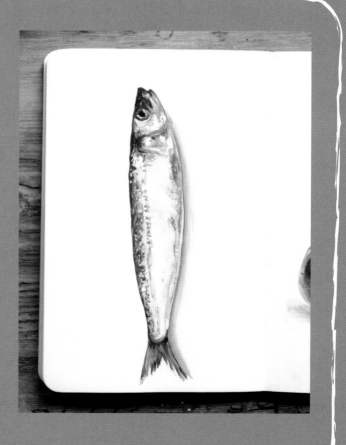

Bonus Day 31: Embellish

It has been quite a journey!

Please do take a moment to pat yourself on the back for committing to this project. Like me, you may have encountered hurdles along the way: art that didn't go to plan, techniques that were difficult to grasp or bouts of procrastination. But, however smooth or laborious your journey here, just bask in the fact that you made it.

Well-done for dedicating this precious time to your art, and, especially, to yourself. And, whether you feel like you need a break from your sketchbook now, or you're raring to go and finish the rest of it, know that its pages are always there to create in without judgment.

Now, celebrate the efforts of your work this month and look back on what you've achieved. Put on some music, a podcast or your favorite show, gather your sketchbook and your most-used supplies, and work your way through, flipping from one page to the next and filling any half-finished pages with notes, patterns, swatches, stickers or taped-in scraps. If you have nothing to add, simply honor all the time and hard work spent on these pages by looking through each of them again with fresh eyes and applauding the artist who filled them.

ACKNOWLEDGMENTS

I'd like to give a special mention to the wonderful makers of the handmade sketchbooks I used throughout this book: Autumn Chiu of Sketchbook Co. (sketchbookcoshop.com) and Helen of pebblepeoplepaper on Etsy (www.etsy.com/shop/pebblepeoplepaper). The level of craft and artistry they put into making these books gave my notes, sketches, experiments and finished paintings the most welcoming and cherished home.

I'm also endlessly grateful to Lauren, Meg, Molly, Kylie and the rest of the team at Page Street Publishing and my lovely editor, Aïcha Martine Thiam, without whom this book would not have existed. Thank you to my copyeditor, Dianne Cutillo, as well.

Thanks also to all the friends and family who checked in with me through the entire process, to Ozzy who inspired and encouraged me and kept me fed along the way, and to Thierry, our cat, for keeping my lap warm while I worked.

ABOUT THE AUTHOR

Minnie Small is a self-taught artist from South East London, where she lives with her husband, Ozzy, and their cat, Thierry. With countless full—and even more half-finished—sketchbooks and journals under her belt that date back to early childhood, she now shares her experiments and explorations in art to an online following of hundreds of thousands of fellow creatives. Follow more of her work at: minniesmall.co.uk.

INDEX

A

Alternative Self-Portrait, 160–163

analogous colors, 29

Argenteuil (Monet), 75

B

backgrounds and additions, 18

Ballpoint Pen Sketching by Drawing These Scissors, 44–48

Basics of Calligraphy with This Writing Exercise, 64–67

Basics of Color Theory with Swatching and Color-Mixing, 30–32

Beginner's Pencil Sketching and Shading while Drawing an Ear from Memory, 33–36

Black Paper, 55–57

Blank Page, The, 10

boxes, 18

C

calligraphy, 64–67

Capturing Important Details by Painting This Tiny Snake Plant, 145–148

Capturing the Basics of the Human Form with a Figure Study, 38–42

Close-Up, 155–159

Collage Paintings, 118–123

Collections I-Objects, 44–49

Collections II-Sketchdump, 69–73

Color Challenge, 130–134

Color Harmony, 28–29

Color Mixing by Painting a Portrait with a Limited Palette of Blue and Red, 141–143

Color Palettes I-Color Harmony, 28–29

Color Palettes II-Limited Palettes, 141–144

colors

analogous, 29

complementary, 29

harmonized color palette, 32

limited palettes, 141–144

monochrome, 28, 91–95

split-complementary, 29

triadic, 29

Combining Ink Drawing with Watercolor with This Croissant Painting, 115–116

Commission Yourself I-Ink Illustration, 124–128

Commission Yourself II-Flat Illustration, 150–154

complementary colors, 29

Creative Journaling with a Collage and Page Layout Ideas, 17–20

D

Detailed Colored Pencil Blending and Drawing a Nose, 105–107

Detailed Pencil Sketches with This Origami Crane, 84–88

Detailed Watercolor Painting by Painting a Blue Jay, 130–133

diamond patterns, 80

E

Easy Watercolor Patterns to Decorate Pages, 11–14

Embellish, 171

Exercises

Ballpoint Pen Sketching by Drawing These Scissors, 44–48

Basics of Calligraphy with This Writing Exercise, 64–67

Basics of Color Theory with Swatching and Color-Mixing, 30–32

Beginner's Pencil Sketching and Shading while Drawing an Ear from Memory, 33–35

Capturing Important Details by Painting This Tiny Snake Plant, 145–148

Capturing the Basics of the Human Form with a Figure Study, 38–42

Color Mixing by Painting a Portrait with a Limited Palette of Blue and Red, 141–143

Combining Ink Drawing with Watercolor with This Croissant Painting, 115–116

Creative Journaling with a Collage and Page Layout Ideas, 17–20

Detailed Colored Pencil Blending and Drawing a Nose, 105–107

Detailed Pencil Sketches with This Origami Crane, 84–88

Detailed Watercolor Painting by Painting a Blue Jay, 130–133

Easy Watercolor Patterns to Decorate Pages, 11–14

Flat, Colorful Illustration Style and Designing a Book Cover, 150–154

Fun Watercolor Brush Techniques and Painting a Page of Leaves, 81–82

Ink Drawings and Illustrate a Poem with Me, 124–128

Landscape Painting with This English Countryside Scene, 136–139

Layering and Shading with Watercolor by Painting a Waterfall Scene, 91–95

Painting a Detailed Pair of Cherries, 165–169

Painting and Collage Technique with This Penguin-Man, 118–123

Practice Gouache Blending and Gradients, 109–113

Realistic Pencil Drawings by Drawing a Water Droplet, 155–157, 159

Seeing Key Values and Shapes by Drawing This Miniature of a Famous Painting, 76–78

Simplifying Shapes by Drawing a Calla Lily, 59–62

Simplifying Shapes Painting Beautiful Trees, 23–25

Stylized Ballpoint Pen Sketches, 69–73

Urban Sketching Techniques with This Drawing of a Building, 99–104

Using Colored Pencils and Drawing a Bubble, 55–56

Using the Paint-Tiling Technique to Paint a Mouth, 160–163

Van Gogh's Painting Techniques in The Starry Night Study, 50–53

F

Flat, Colorful Illustration Style and Designing a Book Cover, 150–154

Flat Illustration, 150–154

Frost, Robert, 129

Fun Watercolor Brush Techniques and Painting a Page of Leaves, 81–82

G

Gesture Drawing, 38–42

gouache paint blending, 110

grid pattern, 80

H

headings and quotes, 18

I

In My Sketchbook
calligraphy, 68

collage painting, 123

color patterns, 32

colored pencil drawing and toned paper, 108

decorating pages, 15–16

drawing a still life, 90

drawing everyday items, 49

drawing from memory, 36–37

figure study, 43

illustrate a poem, 129

illustrating a book cover, 154

illustrating breakfast items, 117

journaling and collage, 21

limited palettes, 144

master study, 54

minimal flower drawing, 63

monochrome painting, 96

painting blue items, 134

plein air painting, 140

realistic painting, 170

repeated patterns, 83

sketchdump, 74

sketching realistically with a
close-up drawing, 159

sky and seascapes, 114

stylizing a self-portrait, 164

thumbnailing, 79

timed drawing, 26–27

tiny paintings of household
items, 149

travel journaling, 104

using black paper, 57

Ink Drawings and Illustrate a Poem
with Me, 124–128

J

journaling, 17–20

K

Klimt, Gustav, 54

L

Landscape Painting with This
English Countryside Scene,
136–139

Layering and Shading with
Watercolor by Painting a
Waterfall Scene, 91–95

Limited Palettes, 141–144

M

Mada Primavesi 1912 (Klimt), 54

Master Study, 50–53

Melville, Herman, 154

Miniatures, 145–148

Minimalism, 59–63

Moby Dick (Melville), 154

Monet, Claude, 75

Monochrome, 91–95

monochrome colors, 28

"My Shadow" (Stevenson), 124

N

Nosferatu, 79

O

Objects
 drawing everyday items, 49
 drawing scissors, 44–48

Observational Drawing, 84–88

Oceans and Skies, 109–113

offset grid pattern, 80

P

Painting a Detailed Pair of
Cherries, 165–169

Painting and Collage Technique
with This Penguin-Man, 118–123

paint-tiling technique, 160

patterns
 harmonized color palette, 32

 repeated, 80–83

 watercolor decorations, 11–14

photos and collage, 18

Playing with Scale I-Miniature,
145–148

Playing with Scale II-Close-Up,
155–159

Plein Air, 136–140

Practice Gouache Blending and
Gradients, 109–113

Prompts
 blending colors, 113

 collage painting, 123

 color mixing with limited
 palettes, 144

 colored pencil drawing and
 toned paper, 108

 drawing a still life, 88–89

 drawing everyday items, 49

 drawing from memory, 36

 harmonized color palette, 32

 illustrate a poem, 128

 illustrating a quote, 67

 illustrating an album or book
 cover, 154

 illustrating breakfast items, 117

 journaling, 20

 master study, 53

 minimal flower drawing, 63

monochrome painting, 95

movement and gesture, 42

painting blue items, 133

plein air painting, 140

realistic painting, 170

repeated patterns, 83

sketchdump, 73

sketching realistically with a close-up drawing, 159

stylizing a self-portrait, 164

thumbnailing scenes from a film, 78–79

timed drawing, 25

tiny paintings of household items, 148

transforming sketchbook pages, 15

travel journaling, 104

white pencil drawing, 57

R

Raphael, 79

Realism, 165–170

Realistic Pencil Drawings by Drawing a Water Droplet, 155–159

Recipe, 115–117

Repeated Patterns, 80–83

S

Seeing Key Values and Shapes by Drawing This Miniature of a Famous Painting, 76–78

self-portraits, 160

shading, 126, 131

Simplifying Shapes By Drawing a Calla Lily with a Single Line, 59–63

Simplifying Shapes with an Easy Way to Paint Beautiful Trees in 1 Minute, 23–25

sketchbooks

breaking in, 10, 15

daily practice and, 7–8

decorating pages, 11–14

page layout ideas, 17

supplies for, 8

Sketchdump, 69–73

split-complementary colors, 29

Starry Night, The (Van Gogh), 50

Stevenson, Robert Louis, 124

still life drawing, 88–89

"Stopping By Woods on a Snowy Evening" (Frost), 129

Stylized Ballpoint Pen Sketches, 69–73

T

Thumbnailing, 75–78

Timed Challenge, 23–25

Toned Paper, 105–108

Travel Journal, 98–103

triadic colors, 29

U

Urban Sketching Techniques with This Drawing of a Building, 99–104

Using Colored Pencils and Drawing a Bubble, 55–56

Using the Paint-Tiling Technique to Paint a Mouth, 160–163

V

Van Gogh, Vincent, 50

Van Gogh's Painting Techniques in The Starry Night Study, 50–53

W

Watercolor Patterns, 11–14

White Pencil Drawing, 57

Words, 64–67

writing, 18

Z

Zorn palette, 141